Strangely Familiar

narratives of architecture in the city

edited by Iain Borden, Joe Kerr, Alicia Pivaro, Jane Rendell
designed by Studio Myerscough

London and New York

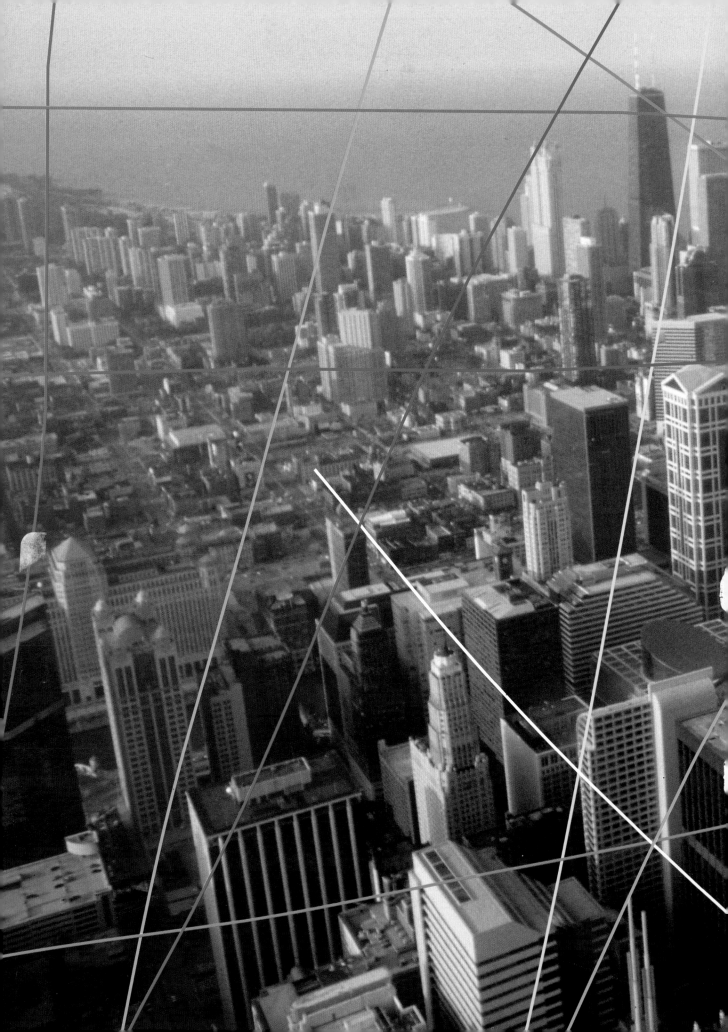

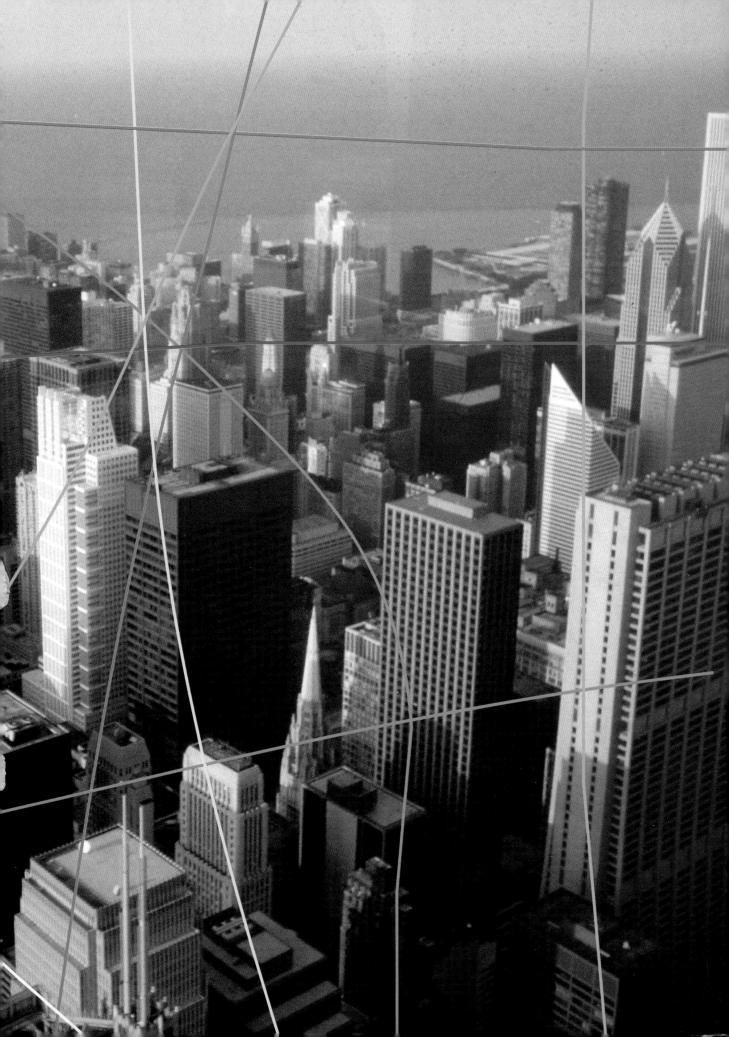

FOREWORD

Fifteen years ago, dismayed by the failure of architectural history to throw any light on architecture's relationship to the rest of the world, a group of us in The Bartlett at University College London came together to try to change this state of affairs. While other disciplines – art history, literature, film studies – had interesting things to say about the way these practices had contributed to the making of so-called "reality", architectural history, despite the obvious significance of architecture in shaping experience, seemed permanently stuck in a backwater of archaeology and attribution. In rethinking the subject, we approached architecture not as a series of monuments, but as a process – a process in which the monuments themselves were just one stage. Initially, much of our interest was in how architecture was made – how a plot of land could be the vessel into which money, labour, political concerns, social values and artistic ideas could flow to realise architecture. Influenced as we were by Manfredo Tafuri, we tended to see architecture as "congealed ideology".

Over the years, our interests have moved on: a criticism of the earlier phase was the tendency to assume that the historian's work ended at the moment in history when the building was finished. On the contrary, as the editors of this book (all of whom are or have been associated with the group of historians at The Bartlett) argue, this is the very point at which the historian's work should *begin*. To concentrate exclusively on the making of architecture is to miss the point that architecture, like all other cultural objects, is not made just once, but is made and remade over and over again each time it is represented through another medium, each time its surroundings change, each time different people experience it.

Strangely Familiar, which comes out of discussions amongst the group who have at various times worked or studied in The Bartlett, is about that most elusive of historical questions, the interpretation of people's social experience of spaces and buildings. Much of the inspiration for this work comes from social geography and cultural studies, but whereas writers in those subjects have tended to look at individual places or buildings only in so far as they illustrate general theories or ideas, contributors to this volume travel in the opposite direction. From looking at specific characteristics of a variety of individual spaces and buildings, they reflect on general questions such as how places can shape, or be shaped by, social identities.

This very welcome collection of essays suggests the mutual benefits to be had from a free trade in ideas between different disciplines. More particularly, *Strangely Familiar* shows that the close study of architecture need not be a matter only for specialists, but can, as we always thought, be of interest and value for anyone whose business is the understanding of culture in general.

ADRIAN FORTY
The Bartlett, University College London

OTHER HISTORIES

NARRATIVES OF ARCHITECTURE IN THE CITY

Strangely Familiar is a loose affiliation of academics, journalists, designers and other urbanists interested in the city. The group was co-founded in London in September 1994 by Iain Borden, Joe Kerr, Alicia Pivaro and Jane Rendell. Each member brings a different set of experiences, agendas, and expertise to the group. This mix of personalities and professional interests reveals a belief that underpins all our activities – the need for different disciplines to communicate. The inter-disciplinary boundaries which divide much academic thinking about architectural and urban issues need to be broken down, and likewise connections need to be made between those who write theories and histories of the city and those who build cities in order to have the greatest impact on the built environment. But, perhaps most important of all, there is a pressing need to interest and include the public in all our architecture, cities and histories.

The desire to cross boundaries of knowledge and expertise extends to all aspects of the Strangely Familiar project. Thus this book, our first manifestation, results from a collaboration between the editors and the graphic designers Morag Myerscough and Belinda Moore of Studio Myerscough, in which text and visual identity are integrated on the basis of parity. The mutual ambition of all those involved in this synthetic process is to produce a document that is both visually stimulating and accessible, particularly in comparison with more conventional academic texts and publications.

The group was formed to create an operative structure to develop projects which deal with issues relating to an understanding of our lives in the modern cities of the world. The driving premise behind the activities of Strangely Familiar is that architecture is the most pervasive form of historical evidence, being an active history that impacts on and informs our everyday lives in the spaces and places we use. As such, the buildings, the streets and public places of the city are at once a familiar backdrop to the city dweller, but also contain the potential to intrigue and amaze when seen and understood in a different way.

Strangely Familiar is a cultural and educational initiative which aims to explore, understand and communicate the complex intersection of architecture, cities and urban living. It does so in three ways: publicly, by

presenting and promoting new ideas about architecture and cities to the general public; professionally, by presenting to architects and other urban design professionals new ideas about cities and urban living; and academically, through inter-disciplinary enquiries involving architectural history, art history, cultural studies, feminism, planning, sociology and urban geography.

The catalyst for the first Strangely Familiar project was an invitation by the RIBA Architecture Centre to curate an exhibition of architectural history. Within an institution that primarily focuses on architecture and the city at the point of construction, the group have used this opportunity to offer a different reading — that what is interesting about buildings is the ways in which they are used. In other words, Strangely Familiar presents the notion that architecture and cities are far more than architects and planners often consider them to be. The focus is on architecture and urban design as they impact on a myriad of intriguing and unexpected urban conditions world-wide. Although academic in content, contributions address real events, real places and real cities, allowing the intersection of different disciplines to take place on the common ground of the buildings and cities in which we live.

The initial venue of the Strangely Familiar exhibition at the RIBA Architecture Centre is a challenging location to meet two aims of the group. First, the RIBA Architecture Centre aims to involve wider community interest and participation in architecture. The exhibition similarly seeks to promote architecture as it involves the general public. Second, Strangely Familiar seeks to promote new ideas about urban life to architects and the RIBA is the primary venue for architects to visit architectural exhibitions. The difference is that Strangely Familiar presents new ideas about how buildings and urban space are occupied, perceived and change over time – concerns rarely considered at such events.

In recent years, cities and architecture have become central to public and media debates about contemporary society. Questions as to what constitutes architecture and urban space, and who should dictate and control their character, are increasingly coming to the fore. Further, in academia, developments concerning cities and public space in urban

geography, gender studies and cultural studies are increasingly influencing architecture, urban planning and architectural history. The Strangely Familiar programme provides the first opportunity for many of the most influential participants in this debate to come together and promote and discuss their ideas with particular relevance to architecture and real city spaces.

Strangely Familiar presents the work of 15 teachers, writers and thinkers from both within and outside the immediate architectural and planning world, who together form a strongly multi-disciplinary team (including architectural history, art history, urban history, feminist theory, urban geography, urban planning, cultural theory and sociology). It also reflects the international dimensions of this work, with contributors from other European countries and from the USA, and stories about Amsterdam, Berlin, London, Los Angeles, New York, Naples, Manchester, São Paulo and Venice.

Instead of following the more usual, yet impersonal, call for papers, each of the contributors was invited to be part of the project because of their specific approaches and subject matters. The contributors are people with whom the group has personal and professional contact and those whose work has been considered to be influential to the Strangely Familiar project, in terms of the development of our own thoughts and ideas, and of the aims of the group collective. The group of contributors as a whole therefore consists of a mix of young professionals and more established names in different fields of activity. Once again this brings into play a desire to create the space for debate and discussion between not only different disciplines, but also different generations and professional hierarchies.

Although it was intended that the contributions investigate a diverse range of different subjects and adopt a range of political, interpretive and analytical procedures, it is also the case that the work as a whole shares a number of presuppositions. This can be broadly summarised by thinking of the project in terms of the following categories:

OTHER HISTORIES

By choosing different objects of study such as unusual buildings and city spaces, events often considered insignificant historically and

perspectives rarely voiced, new histories of the city can be told. This approach defies geographical and architectural centralism, in which canonic buildings and urban spaces take centre stage. In some ways this critiques various systems of domination, like capitalism, patriarchy and cultural and racial élitism. Contributors identify both new ways of thinking about capitalist space and architecture, and ways of resisting it, either through utopian fragments or through real practices that rub against the grain.

REAL PLACES

Understanding cities and architecture – and communicating that understanding – involves telling real stories about real places. Although many of the contributions are driven by or founded on social, cultural and urban theory, in Strangely Familiar they largely foreground the material and ideological reality of architecture and cities. For the exhibition and for this document, contributors avoid overtly or purely theorised texts/language, and focus instead on particular contemporary and historical instances of urban life. In short, each contributor relates an urban narrative about a particular place, time or set of events, and in a way that is accessible to all.

EVERYDAY LIFE

Architecture and cities are matters of production and reproduction that involve more than the design professions of architecture and planning. Instead they form the scenery for our lives. Acts of use and appropriation; unusual and counter-cultural social practices; changing meanings over time; issues of gendered, cultural, ethnic and class identity and different urban experiences are used to re-think what should be considered as "architecture".

NARRATIVES

By using a narrative format, a route is provided which can introduce the unexpected and unfamiliar. The different kinds of events which people experience and find significant all provide a questioning of our understanding of the city. If you dig beneath the surface then you discover the unexpected. This process can reintroduce the city to the urban dweller, offering an opportunity to discover something new, and through their own agendas and perspectives find a new mapping and a way of thinking about cities. The strange becomes familiar and the familiar becomes strange.

ELISABETTA ANDREOLI, Italian born, has been in London for many years, where she took her degree in History of Art (University College London) and MSc in the History of Modern Architecture (The Bartlett, University College London). A metropolitan dweller – she has also lived in Rome, São Paulo, Paris and Bogota – she is concerned with understanding the nature of the metropolitan experience with particular reference to the city of São Paulo and its geo-political location. She works as a researcher, freelance writer and exhibition organiser in the field of art, architecture and education. In 1994, she was responsible for bringing to the Royal Institute of British Architects in London the exhibition "Life and Work of Lina Bo Bardi", an Italian-born architect based in Brazil.

IAIN BORDEN, a former (and still occasional) skateboarder, lectures in architectural and urban history at The Bartlett, University College London, where he has taught since 1989. He was educated in architectural, art, planning and ancient history at the University of Newcastle-Upon-Tyne, University College London and University of California at Los Angeles. He is currently working on aspects of the historical study of spatiality, and particularly with the role of architecture in the context of the city as the space of flows of ideas, events and activities. He is co-editor of *Architecture and the Sites of History: Interpretations of Buildings and Cities*, (1995).

M. CHRISTINE BOYER, a native of Manhattan – a site selected by her mother from London and her father from California – now resides in the West Village. She was an early devotee of computers and a developer of programming languages. These endeavours were abandoned in the '60s for the city, when Detroit, Los Angeles, Newark began to burn, while the bulldozers of urban renewal tore out the heart of the cities. Boyer is Professor of Urbanism at the School of Architecture, Princeton University. She has taught at Harvard Graduate School, Columbia University School, Cooper Union Chanin School and Pratt Institute. She is author of *Cybercities: Visual Perception in the Age of Electronic Communication,* (1996), *The City of Collective Memory,* (1994), *Dreaming the Rational City,* (1983), and *Manhattan Manners: Architecture and Style 1850-1890,* (1985). She is currently researching *The City Plans of Modernism*.

IAIN CHAMBERS teaches at the Istituto Universitario Orientale, Naples, and has worked on metropolitan cultures, in particular on urban cultural practices and the centrality of popular music as a palimpsest of memories and identities. His studies draw upon inter-disciplinary critical approaches, and his recent work has been pursued within the context of the increasing globalisation of economic and cultural relations and emerging cultures of hybridity. His writings have appeared in English, Italian, Japanese and Spanish. Among his publications are: *Migrancy, Culture, Identity,* (1994); "History, the Baroque and the Judgement of Angels", *New Formations,* n.24 (Winter 1994); *Border Dialogues: Journeys in Postmodernity,* (1990); and *Popular Culture: the Metropolitan Experience,* (1986).

JONATHAN CHARLEY is a Lecturer in Architecture at Strathclyde University. He studied architecture at Portsmouth, worked for six years in a building and design co-operative, and has a master's degree from The Bartlett, University College London. He studied history for a year at the Moscow Institute of Construction and Engineering, and has recently completed a PhD concerned with a materialist theory of the production of the built environment that explores general issues concerned with the labour process through an historical analysis of the Russian and Soviet experience; a book on the subject is on its way. He has published widely in Europe.

BARRY CURTIS is Head of the School of History and Theory of Visual Culture at Middlesex University. He has been editor of the journal *BLOCK* in its various manifestations since 1979 and has written on a range of issues, including tourism, ethnicity, film and design. A long standing Venetian tourist, he is currently very interested in "the future" and the various ways that it has been conceived, implemented and frustrated.

DOLORES HAYDEN, historian and urbanist, is Professor of Architecture, Urbanism, and American Studies at Yale University. She writes about the social and political history of American built environments, and about the politics of design. Her books include *Seven American Utopias: the Architecture of Communitarian Socialism, 1790-1975,* (1976); *The Grand Domestic Revolution: a History of Feminist Designs for American Homes, Neighborhoods, and Cities,* (1981); and *Redesigning the American Dream: the Future of Housing, Work and Family Life,* (1984). As founder and president of The Power of Place, she spent eight years developing collaborative projects with historians, artists and designers to celebrate the history of women and ethnic groups in public places in Los Angeles, the subject of her newest book, *The Power of Place: Urban Landscapes in Public History,* (1995).

JOE KERR is Senior Lecturer in the history and theory of architecture at the University of North London and Middlesex University. He holds a degree in art history and a master's degree in architectural history from University College London. He has written and broadcast on twentieth century British culture, and confesses to a certain nostalgia for the political and social values of modernism. He is currently writing, with Murray Fraser, a book entitled *Architecture and the Special Relationship: the Influence of America on British Architecture Since 1945.* He maintains a passionate enthusiasm for London, despite the devastation of the city's social and physical fabric in recent years.

SANDY McCREERY teaches architectural history and urbanism at Winchester School of Art and several universities in London. He believes that, throughout history, culture has been most fundamentally shaped by the available means of communication. Further, urban culture is currently threatened both by the revolution in information transfer and the exponential rise in the consumption of transport distance. He loves cities, and bikes, and hopes for a more enlightened government policy for London soon.

DOREEN MASSEY is author of *Space, Place and Gender*, (1994), joint editor of the new journal *Soundings*, and originator of the Bill Shankly "Philosophy of Football" T-shirt. She is also Professor of Geography at the Open University. Her other publications include (co-ed.), *A Place in the World?*, (1995), (co-ed.), *Geographical Worlds*, (1995) and *Spatial Divisions of Labour*, (1984).

WILLIAM MENKING is an architectural and urban historian, and Assistant Professor of City Planning and Architecture at Pratt Institute in New York. Born in Puerto Rico he emigrated to the United States to pursue education and employment opportunities. Degrees in architecture, architectural history and city and regional planning have led to employment as a union organiser for Caesar Chavez, owner of an architecture tour business in New York and Art Director for Miami Vice. Critical writings have appeared in various journals, magazines, and newspapers in the United States, Britain and Europe. He is currently writing architectural and urban criticism for *Time Out*, New York.

ALICIA PIVARO is a journalist, exhibition curator, and architectural designer. After training as an architect at the Bartlett, University College London, with a MSc in History of Modern Architecture, she worked for the Design Council. She was the writer of *Urban Design – Terry Farrell*, (1993), and has taught architectural history at Middlesex University and the University of North London, but as a freelance doer of things she most enjoys promoting architecture and design to beyond the egotistical clique of the professions. Her main project at present is a television series that looks at how design, in its widest sense, affects modern urban life and culture.

JANE RENDELL is a committed socialist, and following her childhood in Ethiopia and Afghanistan to her travels in USSR, Cuba and South/Central America, she promotes these issues in all aspects of architectural practice. She is also a committed feminist, and, having trained as an architect at the universities of Sheffield and Edinburgh, she has worked in community oriented offices, including a feminist co-operative. She has a master's from the University of London and has published on feminism and architectural/urban issues. Presently living in London and funded by the British Academy, she is conducting her PhD research at Birkbeck College into gender and architecture in early nineteenth century London. She teaches gender studies, urban history and architectural design at University College London, Winchester School of Art and De Montfort University, Leicester.

EDWARD W. SOJA, formerly Associate Dean of the Graduate School of Architecture and Urban Planning at UCLA, is currently a Professor in the Department of Urban Planning. From his early research on problems of regional development in Africa to his current work on the postmodernization of Los Angeles, Soja has been concerned with how we theorize space and the politically charged spatiality of social life. He is the author of *Postmodern Geographies: the Reassertion of Space in Critical Social Theory*, (1989) and the just-completed *Thirdspace: Journeys to Los Angeles and Other Real-and-Imagined Places*, (1996), a collection of his writings on critical cultural studies of space, place and the contemporary city. His essay on Amsterdam is included in the volume.

LYNNE WALKER received her PhD at the University of London and was Senior Lecturer in the History of Architecture and Design at the University of Northumbria. After a stint at the Royal Institute of British Architects, she ran the Women's Access into Architecture and Building course at the University of North London and chaired the Women's Design Service. She has served on the Editorial Board of *Art History* and *Women's Art Journal*. In addition to teaching, she is currently involved in the preservation of women's buildings and places and is writing a history of British women and architecture. Her publications include *Women Architects: Their Work*, (1984) and (ed.), *Cracks in the Pavement: Gender/Fashion/ Architecture*, (1992), and she compiled *William Morris*, (1984), the first anthology in Spanish on that subject.

ELIZABETH WILSON is a writer who teaches cultural studies at the University of North London. She was formerly a pyschiatric social worker, but her main interests have always been aesthetics, art and literature. The liberation and left-wing movements of the late 1960s and early 1970s led to her involvement in radical politics and these continue to inform her writing, even if, in her life she has slipped once more into the role of aesthete. Among her non-fiction books, are *Adorned in Dreams*, (1985), *The Sphinx in the City*, (1991), and *Enchanting Bohemia*, (1996). In the past three years she has also published two thrillers, the *Loft Time Café*, (1993) and *Poisoned Heart*, (1995).

In this document we can identify three strategies for engaging with the city: experience and identity; memory and remembering; resistance and appropriation. These three themes can be related to the fifteen essays in this document – but they are by no means exclusive. Contributors' essays overlap considerably (and desirably so) in both their content and resonances. We offer here some thoughts about the relevance of each of these three themes, and some associations with the various essays that follow.

EXPERIENCE AND IDENTITY

Urban meaning is not immanent to architectural form and space, but changes according to the social interaction of city dwellers. Conversely, people's identity in terms of their age, gender, class and culture is partially constructed in relation to the spaces and buildings they occupy. In *Strangely Familiar*, the personal is paired with the physical and the conceptual, and in Manchester's Wythenshawe familial experiences of this garden city reveal political conditions of social experience that are both contained within the ageing body and that resonate far beyond the boundaries of the unique body or site. Similarly, Victorian London's heavily patriarchal private and public spheres are experienced and reconceived in new ways by a number of women's groups and circles, giving them control over their social actions and identity; while the Burlington Arcade of Regency London is disclosed not as a space of shopping used by female consumers and workers (as we might initially think of it) but as a place of prostitution and the commodification of women.

Other cities around the world tell different (and more antagonistic) tales of cultural identity. In São Paulo, the central urban site of the Anhangabaú Valley forms the ground for different and marginalised social groups to occupy the centre, challenging the role of architecture to determine both the identity of those who use it and of the city itself. In Amsterdam, similar socio-spatial tensions appear but in a very different crystallisation, in which a view from a single window of a single house in a single street serves as a partly visual, partly politically-informed experience which highlights the contradictory "repressive tolerance" of Amsterdammers that pervades and structures the spaces of the city.

MEMORY AND REMEMBERING

Choosing what to remember, and deciding how to remember, are important procedures for urban social politics. All too easily history focuses selectively on particular parts of the past, excluding specific sections of the public, or even the public as a whole, in favour of highly legitimised histories of the State and institutional élites. It does not have to be this way. Los Angeles, for example, can reveal almost forgotten histories of its African-American inhabitants – histories nearly erased from the public sphere but now being re-remembered, marked and celebrated. This kind of history can take place in every city; in the London Borough of Finsbury, the rise and fall of the memorial to Lenin, designed by Lubetkin, shows how the British government and people shifted their attitude to Russia during World War II. This kind of remembrance is both important and timely, helping to recall destroyed structures and hidden sets of events, and in the process to resist histories being created today which erase the complexities of the past in favour of reductive accounts that serve the interests of today's ideologues.

The city itself can also be a form of memory, and the hybrid Mediterranean city of Naples perhaps more than any other "offers the heterotopic space of various pasts, multiple presents . . . and diverse futures", where "the linearity of time spirals out into diverse tempos". Another Italian city, Venice, also provides a history and remembrance of itself, but in a very different way to that of Naples. Here, instead of the Neapolitan celebration of urban life, there is an unrelenting tension between the old and the new, in which the ancient fabric so beloved by tourists both hinders the everyday life of Venetians and threatens their ability to confront the future. A project for a Venice Metro system unearths this dichotomy.

And what happens when memory fails us, when we can no longer see the city we wish to remember? In New York, a twice-told story has emerged to remember Times Square, firstly through the extraordinary cognitive mapping of the film *The Naked City*, and secondly through architect Robert A.M. Stern's proposals for a simulation architecture of advertisements, signs and Disney characters on the site itself.

RESISTANCE AND APPROPRIATION

The excesses of capitalism, in order to be resisted and fought against, must first be identified and understood. On the one hand, we can do this through an exploration of the development of universal places and spaces common to all capitalist sites. Such "sentences upon architecture" provide guides to our general condition today. But specific sites offer their own variations and twists upon the general, and in New York we find concerted attempts to ·"cleanse" Grand Central of its "unwanted" uses, where capitalist developers seek to change and control the city as their own reductive.

Such acts of attempted domination may, of course, also be resisted, and in London's elevated Westway we find in the 1960s and 1970s an early protest against road construction, whereby local residents used the national profile of the scheme to secure support for their own aspirations and needs.

Appropriation of space does not, however, always need a grand modernist project to confront, but can use the occasion and fact of the city as the site of interventions and new socio-spatial creations. Many of the essays already referred to above also offer their own form of appropriations. In a particularly explicit form of this strategy, skateboarders, although often disempowered by age and purchasing power, seize and redefine micro-sites of the city to make their own architecture composed of new mappings and ephemeral occupation. Of course, such activities are not new. A long tradition of the city involves those with counter-cultural aspirations to find the gaps in which they can operate. Berlin, as with Paris, provided the ultimate bohemian space – the café. In Berlin, the Café des Westens (like other cafés) gave artists and poets like Else Lasker-Schüler a place to eat, keep warm, write, converse, find work – in short, they made it into their own world.

We would hope that these essays, when taken in combination, and with reference to other manifestations of the Strangely Familiar programme, offer a stimulating multiplicity of readings, and even point toward meanings beyond their own internal concerns. Other interpretations, other histories, other narratives, other places remain to be discovered.

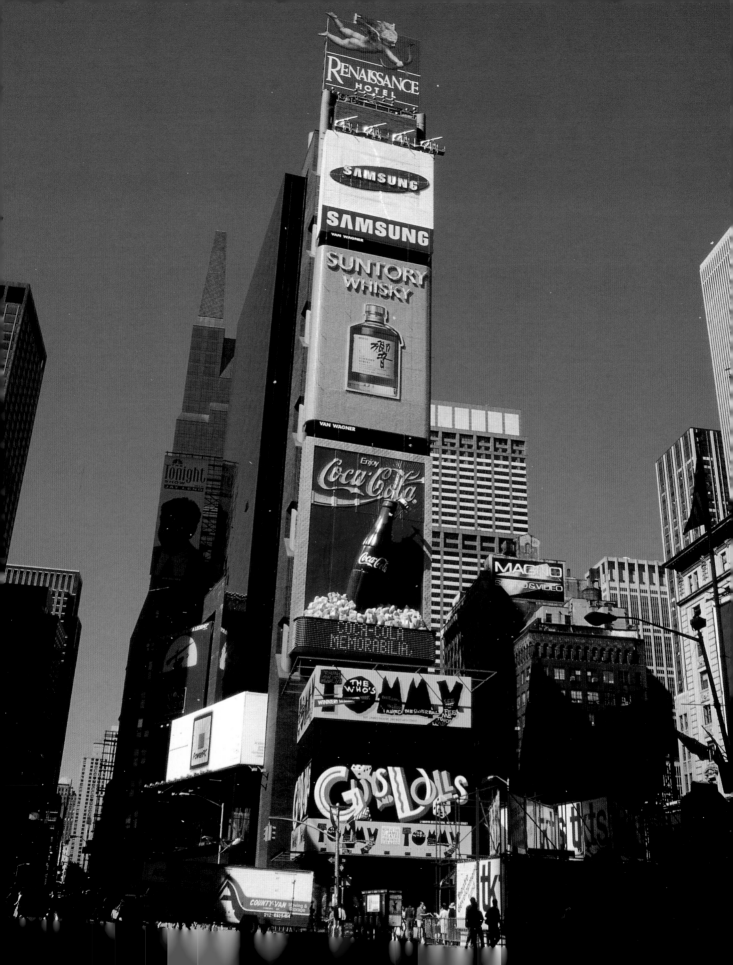

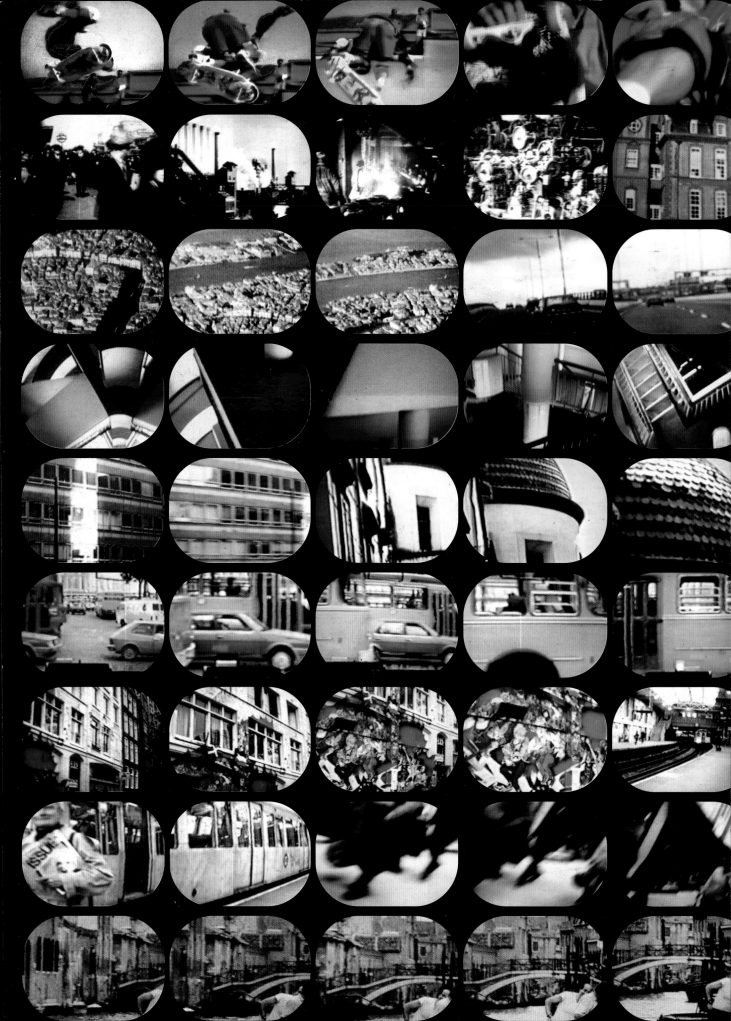

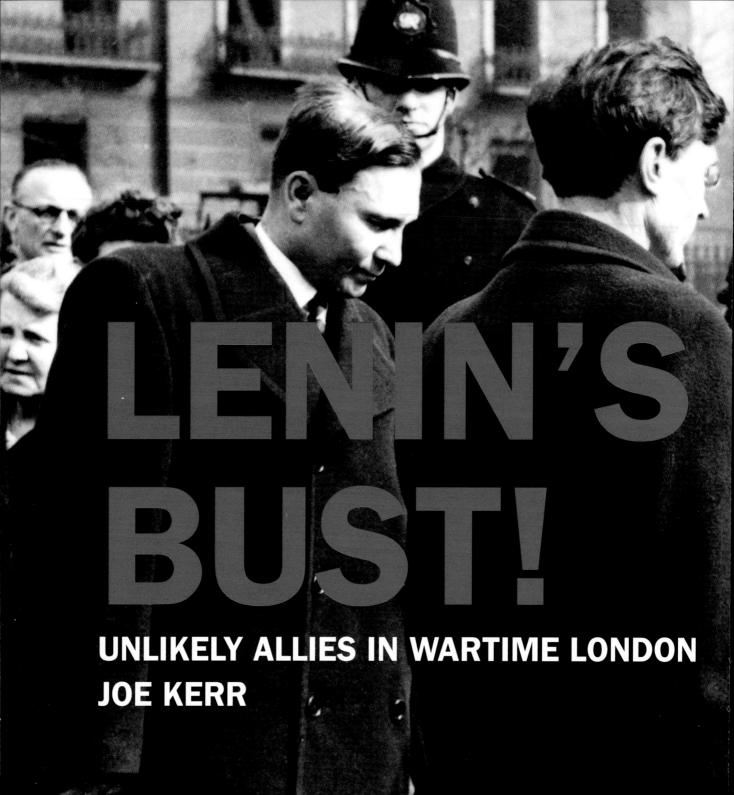

LENIN'S BUST!

UNLIKELY ALLIES IN WARTIME LONDON
JOE KERR

The physical fabric of cities can be seen as a solid record of historical change. But those buildings and spaces may also be th
site for less tangible traces of the past; the memories people hold of significant events are intimately connected with specifi
places. In this narrative, the evidence of a single architectural space is a link to events in wartime London, the memory o
which provides a powerful challenge to accepted interpretations of our recent history.

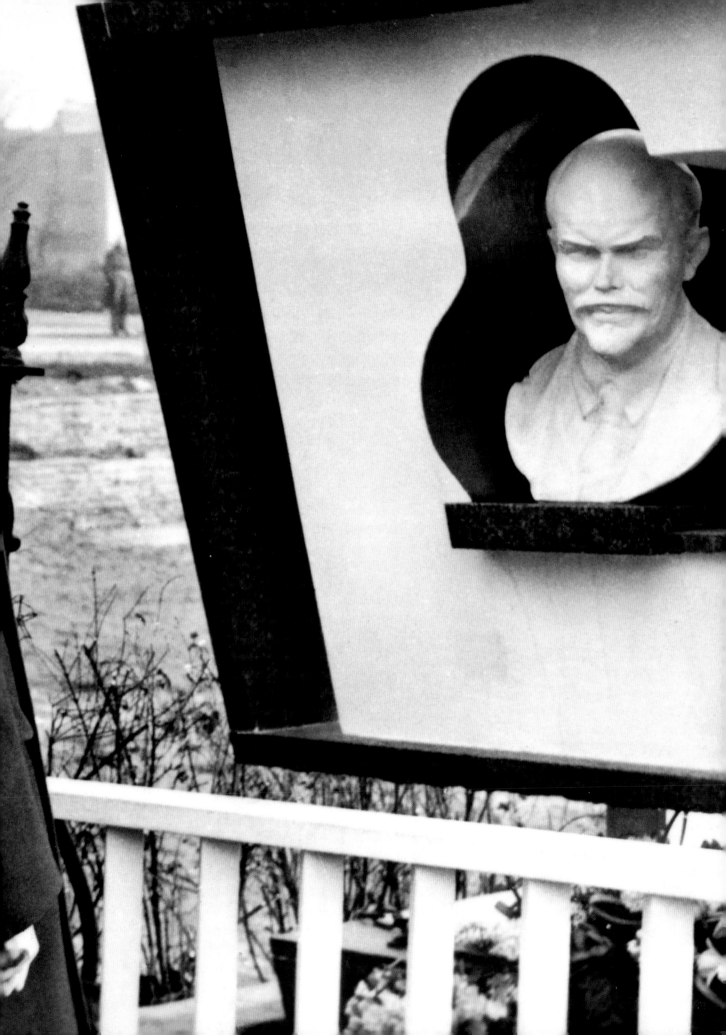

APRIL 22ND 1942

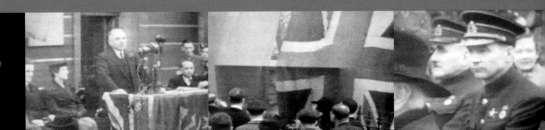

LENIN MEMORIAL UNVEILED

On April 22nd 1942, a dramatic ceremony was performed in a bombed-out London square. The Russian ambassador Maisky and his wife unveiled a monument, pulling back the curtains of Union Jacks and Red Flags to reveal a memorial to the former Soviet leader, V.I.Lenin. In the presence of a sizeable crowd of soldiers, Foreign Office officials – including the Foreign Secretary Sir Anthony Eden – and Soviet dignitaries, Maisky spoke of "the mutual understanding of our peoples" and the need to "defeat and annihilate Hitlerite Germany", and was loudly cheered. A Regimental Band played the Internationale, while a Home Guard detachment stood to attention.

The 17 ton monument of concrete and granite, with a bust of Lenin dramatically lit through red glass, was the work of the Russian emigré architect Berthold Lubetkin, the most celebrated modern architect in pre-war Britain. As a committed Marxist, Lubetkin believed that architecture should serve the cause of socialism, but had previously been denied the chance to demonstrate what this might actually mean.

The unveiling of the bust in Holford Square, Finsbury, was resonant with symbolism; for Lenin had once lived nearby, and it was his birthday. But the timing was of greater significance globally; the German and Japanese war machines were rampant, and demoralising defeat was the daily news in Britain. However, the Soviet Red Army was now holding the Germans at Stalingrad, and in Britain there was massive public support for the valiant Soviet people. This was openly encouraged by Churchill's government, who saw Russia as crucial to allied victory, and who sponsored the memorial.

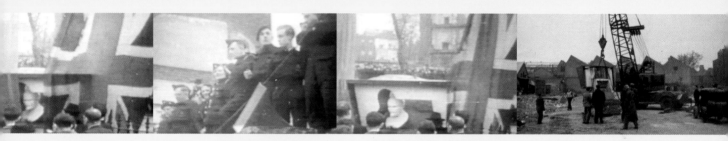

This cameo exemplifies the high idealism borne of wartime desperation, but is equally a supreme illustration of British political pragmatism. Of course, the erection of such a monument is in itself nothing extraordinary; London's public spaces abound with memorials to radicals and revolutionaries. But only under the unique constraints of total war could a monument to the hero of Russia's October Revolution simultaneously serve the political interests of its various promoters – from local Communist activists, to the British and Soviet governments – as well as capturing the general mood of public opinion. And only at this time could the memorial have acquired the political significance with which unfolding events imbued it.

For the Lenin memorial was back in the news a few months later, but in a way which gives an altogether different picture of London at war. In February 1943 it suffered damage at the hands of Fascist protesters. The bust was daubed with the letters

"P.J." – Perish Judah – and the words "Communism is Jewish", together with the Flash symbol of Moseley's fascist Blackshirts. The incident is a sobering contradiction of the most enduring myth of the war; that of the "Blitz Spirit", of ordinary civilians pulling together in the defeat of Hitler. For this authorised version of wartime history it has proved convenient to forget that organised fascist gangs operated in London throughout the war.

The damage to the monument led to national protests, and an embarrassed formal apology to the Soviet government. After it was restored, extraordinary protective measures were introduced; a 24-hour police guard was established, and the architect Lubetkin secretly cast 24 replicas of the bust in anticipation of further vandalism. But events were catching up fast with Lenin's monument, and with the defeat at Stalingrad and the Normandy landings sealing Hitler's fate, the Western allies were thinking of new enemies.

The Cold War was brewing, and it was no longer expedient for the British establishment to celebrate a Soviet hero.

A discreet abandonment of the police guard led to further attacks and in August 1945, less than two weeks after final victory in Japan, a Swastika was drawn on Lenin's forehead. To place this explicit display of Nazi support in context, this was just a few months after the liberation of Ravensbruck, Auschwitz and Belsen, when no one could any longer claim innocence of the horrors of the Third Reich. As the *Daily Worker* noted at the time, "Fascism is defeated not dead". The police guard was repeatedly dropped and reinstated, by which time Lenin had lost a shoulder, his nose, and his ears and the monument was ignominiously concealed beneath a tarpaulin. The government, which was losing face as rapidly as Lenin's bust, discreetly pressured the local council to remove it, and eventually Lubetkin unceremoniously buried it in a hole in the ground.

The shifting fortunes of the Lenin Memorial illustrate how a particular political conflict was manifested and experienced within the context of urban space. Already before the war the struggle between the mass movements of communism and fascism had spilled over into the streets and markets of London's East End, where the conflict of ideas was expressed in pitched battles for territorial control. But during the War, with democratic rights suspended, and with the Blackshirts proscribed, political action was forced underground. Instead, the covert battle for the Lenin Memorial became the locus for this microcosmic eruption of the global conflict.

While Lenin's little monument has left no physical trace, the memory of its brief existence deserves to be remembered. As Dolores Hayden argues elsewhere, "even bitter experiences and fights communities have lost need to be remembered – so as not to diminish their importance". As the real memories of wartime London become merely second-hand, we must preserve those experiences of events and places whose meanings challenge the cosy nostalgia of official histories.

Holford Square cannot be found on a modern street map, for the whole area is covered by a social housing scheme originally planned to protect the monument. The housing estate's proposed name of Lenin Court was subtly changed after the monument's demolition to Bevin Court, in an equally emphatic destruction of meaning. But its dramatic staircase still marks the space of Lenin's Memorial, and provides a last tangible memory of this story.

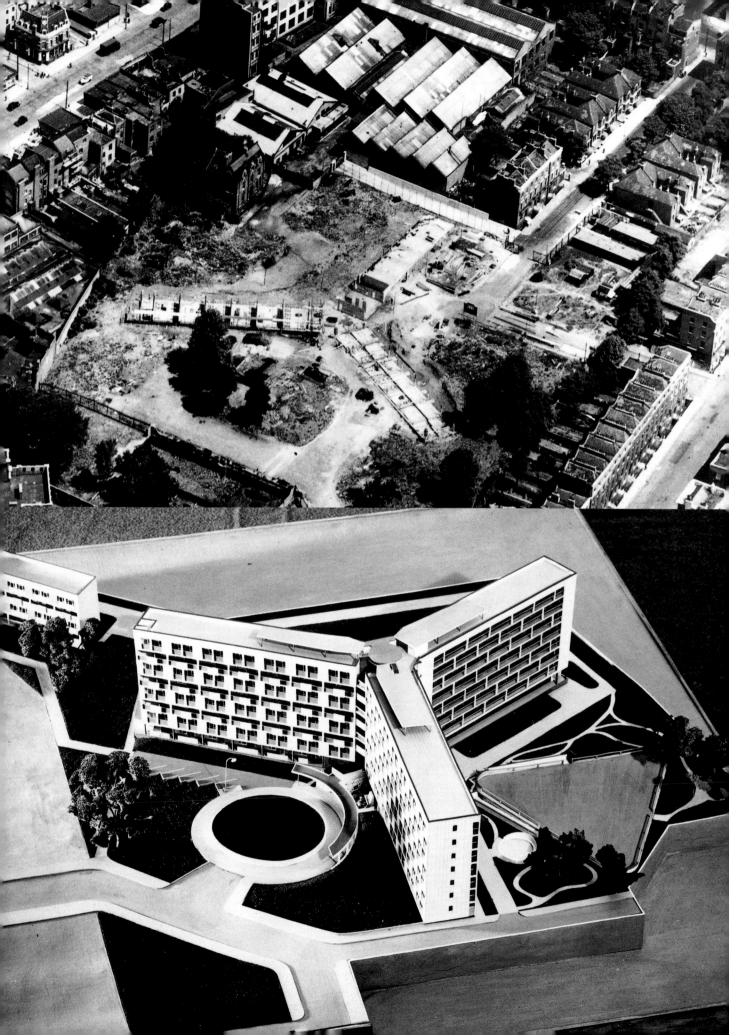

WELL-PLACED WOMEN: SPACES OF THE WOMEN'S MOVEMENT IN VICTORIAN LONDON

LYNNE WALKER

Early in February 1859, and after the proper introductions, two young women strolled from the Rectory of Christ Church, Marylebone, London, to tea with a slightly older woman in her family's house at nearby Blandford Square. This pleasant and, seemingly, purely social activity was in fact a crucial moment in the history of the nineteenth century women's movement. The visitors were Elizabeth Garrett, later Dr. Elizabeth Garrett Anderson, England's first woman physician, and Emily Davies, who became a pioneer in women's higher education. In this domestic setting of a tea party, their hostess, the artist and feminist campaigner, Barbara Leigh Smith Bodichon, recruited them into the Women's Movement.

After tea at Bodichon's house in Blandford Square, Garrett and Davies were sent on a ten minute walk to 14a Prince's Street. Here they found the offices of the *English Woman's Journal*, both established and funded by Bodichon. The journal was the voice and social centre of British feminism. They were welcomed by the dynamic team which ran the journal and its associated activities, including Jessie Boucherett, who organised the Society for Promoting the Employment of Women, (SPEW), and Isa Craig of the National Association for the Promotion of Social Science.

Introductions and encounters such as these could have dramatic ramifications. Within a few years of her first call to the Women's Movement, Davies replaced Bessie Parkes as editor of the *English Woman's Journal*. Davies also successfully campaigned, along with Bodichon, for women's admission to university examinations. Davies and Bodichon together created one of the central achievements of nineteenth century education, the founding of Girton College, Cambridge. For this ambitious venture in women's education, Bodichon's family home was again called into action, this time as an examination hall for the first candidates and later this well-used London town house became a place of entertainment and moral support for Girton students.

Garrett, for her part, after qualifying as a doctor, set up both her home and a series of medical offices, infirmaries and dispensaries in and around the Marylebone area. EGA, as Garrett is still affectionately known, was a tireless leader who promoted women's health, medical training, education and care, not unlike that other Marylebone resident, Florence Nightingale. Nightingale, significantly, was a cousin of Bodichon, and also worked in the Marylebone area. In fact, it was Nightingale's letter of support which ensured the success of Garrett's most enduring achievement, the Women's Hospital in nearby Euston, today the Elizabeth Garrett Anderson and Soho Hospital for Women.

While Garrett, Davies and Bodichon developed feminist initiatives from their germination in Prince's Street, so too did the *English Woman's Journal*. Late in 1859 the journal moved around the corner to number 19 Langham Place. While some of its auxiliary organisations spun off into separate locations nearby, one important facility did stay with the *English Woman's Journal* in its move to Langham Place – the Ladies' Institute. This organisation addressed the problem of poor facilities for women in the public sphere and provided a place where they could eat, read and relax. At a time when women were becoming an ever-increasing presence in the urban realm, toilets were a particular problem, and a collateral organisation to the Ladies' Institute, the Ladies' Sanitary Association, argued for provision of women's toilets in the streets of central London. Despite these efforts, public toilets for women were continually resisted by local authorities and did not appear until the 1880s.

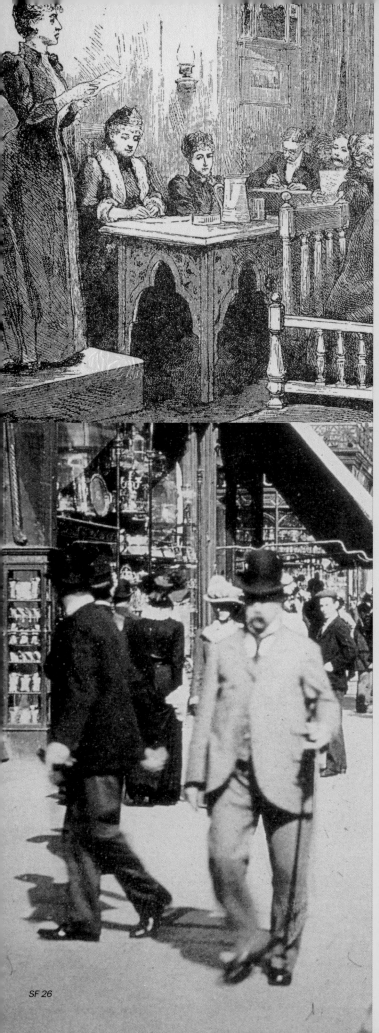

The West End of Victorian London, where all these events took place, is usually understood as the centre of male institutions of power, from which women were excluded. However, from a feminist perspective, another history emerges. Central to this story was the presence in the city of women, many of whom, such as Garrett, Bodichon and Davies, were critical to the struggle for women's rights.

To understand the city, we also need to recognise the sites and spaces, both public and private, which were based on the networks, alliances, and organisations of the nineteenth century Women's Movement.

As we have seen, some Victorian feminists like Bodichon made their homes into effective power bases. Although not new (it was familiar from Anti-Slavery campaigns), the politicized home was a powerful political space for women. For example, Bodichon's house in Blandford Square served many feminist causes including petitioners for the Married Women's Property Bill. Similarly, Emmeline Pankhurst adapted her house in Russell Square for suffrage meetings.

By eliding public and private spheres in these ways, these women created new spaces in the city which challenged the traditional division between the public male space of institutions and the private female space of the domestic home. While the home became both centre and origin of female organisations, the activities of these nineteenth century feminists were not, however, restricted to the domestic space, as we have seen in the offices of the *English Woman's Journal* and the Ladies' Institute. Their presence and propinquity in the city, combined with their relatively privileged backgrounds and positions, helped secure access to the public sphere and facilitated women's participation in public life. Such female lives and spaces constitute a different mapping of the city.

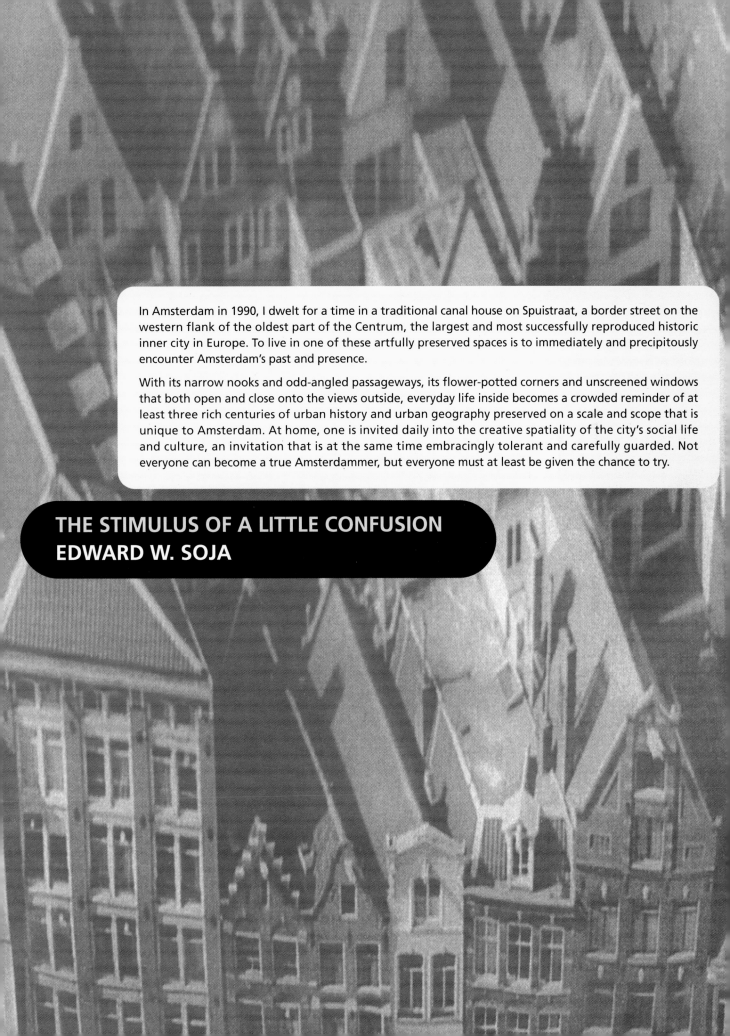

In Amsterdam in 1990, I dwelt for a time in a traditional canal house on Spuistraat, a border street on the western flank of the oldest part of the Centrum, the largest and most successfully reproduced historic inner city in Europe. To live in one of these artfully preserved spaces is to immediately and precipitously encounter Amsterdam's past and presence.

With its narrow nooks and odd-angled passageways, its flower-potted corners and unscreened windows that both open and close onto the views outside, everyday life inside becomes a crowded reminder of at least three rich centuries of urban history and urban geography preserved on a scale and scope that is unique to Amsterdam. At home, one is invited daily into the creative spatiality of the city's social life and culture, an invitation that is at the same time embracingly tolerant and carefully guarded. Not everyone can become a true Amsterdammer, but everyone must at least be given the chance to try.

THE STIMULUS OF A LITTLE CONFUSION
EDWARD W. SOJA

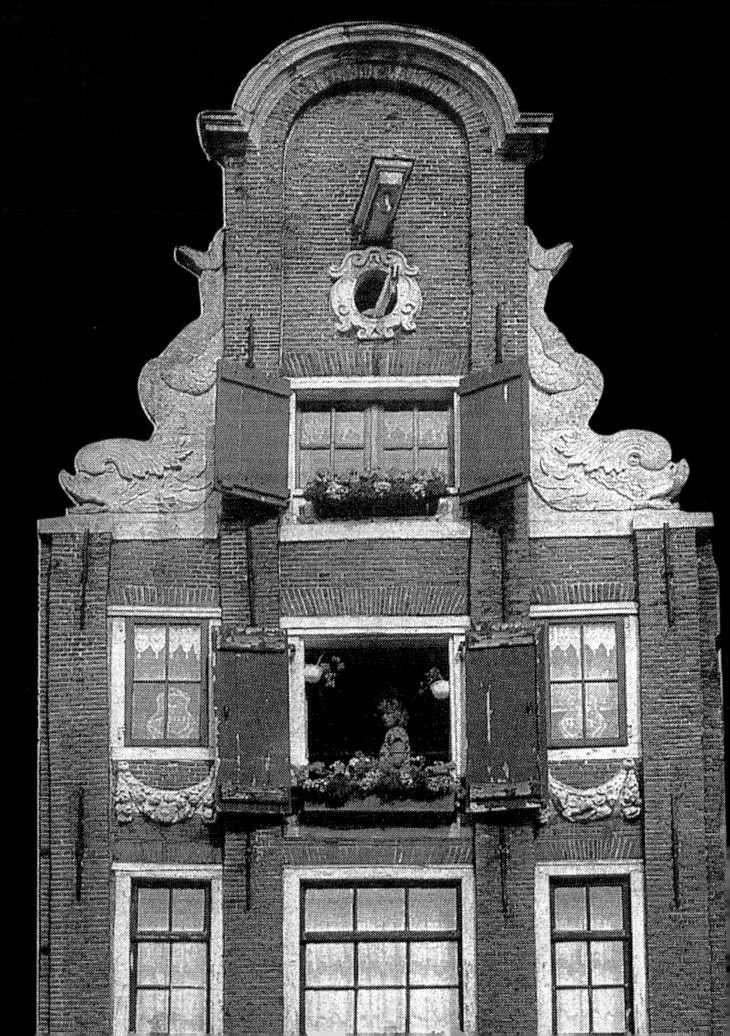

SMASH
THE
STATE
IN Ⓐ
RIOT
OFF
HATE

HOTEL

FUCK
YOU
ALL

199

V
U
C
G
K
O
F

JUSTITIE SPEKT FRAUDEUR

Cherry

PRIVATE PROPERTY

Ⓐ

218
SQUAT
Orchard

The view through my front window was a wonderful illustration of this peculiar urban genius. Immediately opposite, in a building very much like mine, each floor was a separate flat and each storey told a vertical story of subtle and creative city building. It was almost surely a squatter-occupied house in the past and probably still was one now, for Spuistraat has long been an active scene of the squatter movement. On the first floor of the house across the way were the most obviously elegant living quarters, occupied by a woman who had probably squatted there as a student but had since comfortably entered the job market. She spent a great deal of time in the front room, frequently had guests in for candle-lit dinners, and would occasionally wave to us across the street. On the floor above there was a young couple. They were probably still students and still poor, although the young man may have been working at least part time for he was rarely seen, except in the morning and late at night. The woman was obviously pregnant and spent most of her time at home. Except when the sun was bright and warm, they tended to remain away from the front window and never acknowledged anyone outside, for their orientation was decidedly inward. The small top floor, little more than an attic, still had plastic sheeting covering the roof. A single male student lived there and nearly always ate his lunch leaning out the front window alone.

This vertical transect through the current status of the squatter movement was matched by an even more dramatic horizontal panorama along the east side of Spuistraat. To my left, looking north, was an informative sequence of symbolic structures, beginning with a comfortable two-storey corner house that was recently rehabilitated with squatter rentals above, and below a series of shops also run by the same group of rehabilitated and socially absorbed squatter-renters, another of those creative contradictions in terms that characterize Amsterdam. There was a well-stocked fruit and vegetable market-grocery selling basic staples at excellent prices, a small beer-tasting store stocked with dozens of imported (mainly Belgian) brews and their distinctively matching drinking glasses and mugs, a tiny bookstore and gift shop specializing in primarily Black, gay and lesbian literature, a used household furnishings shop with dozens of chairs and tables set out on the front sidewalk and, finally, closest to my view, a small hand-crafted women's cloth hat shop.

This remarkably successful example of the gentrification by the youthful poor is just a stone's throw away from the Royal Palace on the Dam, the focal point for the most demonstrative peaking of the radical squatter movement that blossomed city-wide in conjunction with the coronation of Queen Beatrix in 1980. A more immediate explanation of origins, however, is found just next door on Spuistraat, where a new office construction site has replaced former squatter dwellings in an accomplished give-and-take trade-off with the urban authorities. And just next door to this site, even closer to my window, was still another paradoxical juxtapositioning, one which signalled the continued life of the radical squatter movement in its old anarchic colors.

A privately owned building had been recently occupied by squatters and its façade was brightly repainted, graffitoed, and festooned with political banners and symbolic bric-a-brac announcing the particular form, function and focus of the occupation. The absentee owner was caricatured as a fat tourist obviously beached somewhere with sunglasses and tropical drink in hand, while a white-sheet headline banner bridged the road to connect with a similar squat on my side of the street, also bedecked with startling colors and slogans and blaring music from an established squatter pub. I was told early in my stay that this was the most provocative on-going squatter settlement in the Centrum.

These vertical and horizontal panoramas concentrate and distil the spectrum of forces that have creatively rejuvenated the residential life of the Centrum and preserved its anxiety-inducing superabundance of urban riches. At the center of this rejuvenation has been the squatter movement, which has probably etched itself more deeply into the urban built environment of Amsterdam than in any other inner city in the world. To many of its most radical leaders, the movement today seems to be in retreat, deflected if not co-opted entirely by an embracing civic tolerance that extends even to distributing official pamphlets on "How to be a Squatter". But it has been this ever-so-slightly repressive tolerance that has kept open the competitive channels for alternative housing, counter-cultural lifestyles, and that most vital of rights to the city: the right to be different.

From my vantage point on Spuistraat a moving picture of contemporary life in the vital center of Amsterdam visually unfolded, opening my eyes to much more than I ever expected to see. The view from the window affirmed what I continue to believe is the most extraordinary quality of this city, its unheralded achievement of highly regulated urban anarchism, another of those creative paradoxes like "repressive tolerance", "flexible inflexibility", "squatter-renters" and indeed the "strangely familiar" that two-sidedly filter through the geohistory of Amsterdam in ways that seem to defy comparison with almost any other *polis*, past or present. This deep and enduring commitment to libertarian socialist values and participatory spatial democracy is openly apparent throughout the urban built environment and in the social practices of urban planning, popular culture and everyday life. One senses that Amsterdam is not just preserving its own Golden Age but is actively keeping alive the very possibility of a socially just and humanely scaled urbanism. And it is doing so by adding, to our regular habits of thought, that entertaining stimulus of a little confusion.

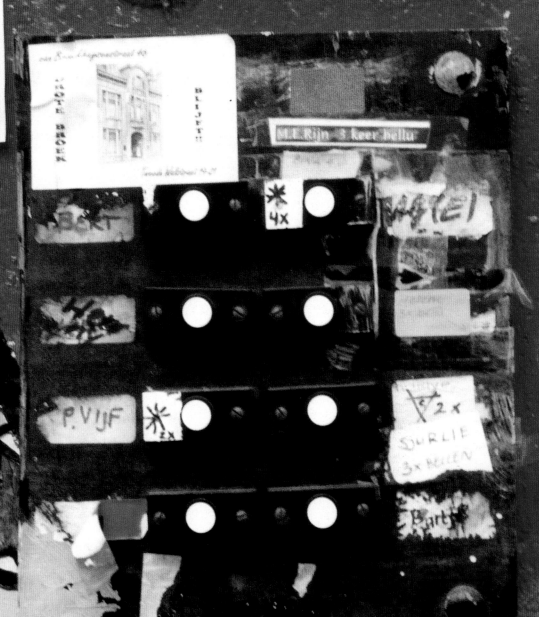

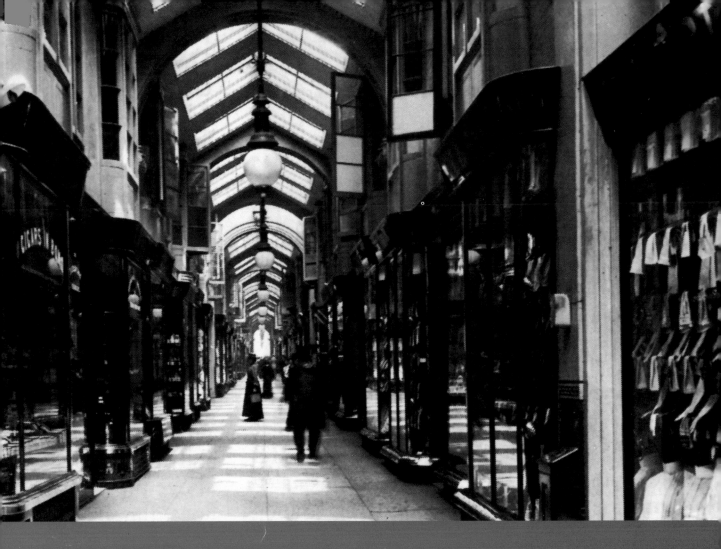

"INDUSTRIOUS FEMALES"
&
"PROFESSIONAL BEAUTIES"

OR FINE ARTICLES FOR SALE IN THE BURLINGTON ARCADE

Jane Rendell

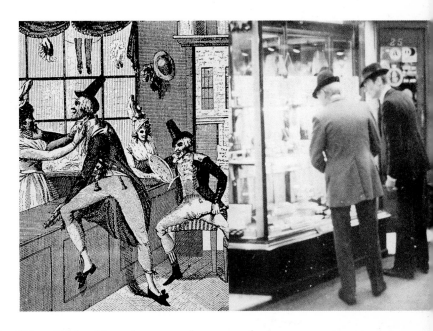

From the early eighteenth century onwards, the West End of London was the most desirable location for upper class life. Directly following the Napoleonic Wars, the area west of Regent Street was developed as a district of luxury shopping venues, including exchanges and bazaars, and the first two London Arcades – the Royal Opera Arcade (1817) and the Burlington Arcade (1818). The Burlington Arcade, built for Lord George Cavendish, was designed by Samuel Ware on a strip of land along the western edge of Burlington House, cutting through from Vigo Street in the north to Piccadilly in the south.

As an architectural and spatial type, the arcade exploits the possibilities of the luxury goods industry by allowing both for pedestrian through-movement and static consumption and display. The Burlington Arcade is a covered and top-lit route, lined on both sides with shop units, whose merchandise is displayed in glazed and projecting bow windows. Architecturally, the arcade is both a long interior room and an external street. Socially, the arcade is both a private and a public space. It is, in theory, open to the general public, but as a privately-owned place there are rules governing social and spatial behaviour, set by the proprietor and enforced by his employees, the Beadles, who thus ensure the arcade operates as an exclusive zone.

This notion that the arcade is a place where the interior and the exterior, the private and the public, intersect is of particular interest to feminists. Patriarchy assumes (and tries to enforce) that space is a binary system of separate and opposing halves, where the city is taken to be the public realm of men and the home is the private realm of women. For feminists, such a distinction is problematic because it does not allow for a full description of both men's, but particularly women's, use and experience of urban and architectural space.

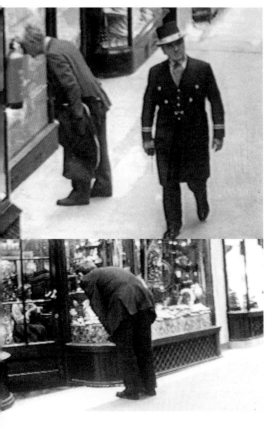

nce, in the early nineteenth century, women increasingly experienced the city through their roles as shoppers and shopgirls, e activity of shopping provides an interesting focus for a discussion of gender and city space in the Burlington Arcade. deed, it was Lord Cavendish's intention to give employment to "industrious females", and a glance at the list of tenants for 328 indicates that a variety of shops sold items with solely female custom in mind, such as millinery and other luxury fash- n goods. The buying and selling of commodities was seen as a respectable urban activity for women. In contemporary rints, the Burlington Arcade was represented as a safe place for women to work and shop in the city. Architecturally, each op is reminiscent of a miniature home, representing gendered images of domesticity and feminine purity.

ut, conversely, shopping venues were also connected with male sexual pursuit and female seduction. In pictures of xchanges, women were frequently the locus of male desire. In poetry and satire, bazaars were considered to be sites of sex- al intrigue, ideal places for picking up a woman, be it a wife, a mistress or a prostitute. The Burlington Arcade itself was oted in semi-fictional guides to London as a place for finding "fresh and fair faced maids". Arcades, in general, were noto- ous for prostitution; the Regent Street Colonnade, for example, was demolished by the middle of the nineteenth century ue to connections with immorality.

ut why should shopping in general, and arcades in particular, be connected with prostitution? And what evidence do we ave for such activities taking place in the Burlington Arcade itself? Here feminist theory offers a different interpretation of e Burlington Arcade, one which looks at the ways in which the arcade represented ideas about gender and sexuality and ne which considers that it was used and experienced differently by men and women. For many feminists, the position of omen in patriarchal society can be compared to that of a commodity. As wives, mothers, virgins and prostitutes, women e the objects of physical and metaphorical exchange among men. Thinking about woman as commodities allows us to ink differently about the relations of men and women in and around the arcade.

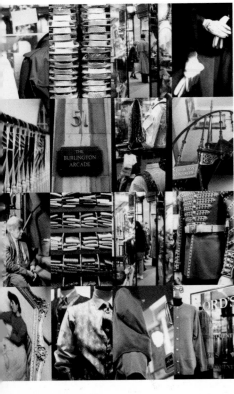

If we consider the location of the arcade in terms of gender and space, we find that in the early years of the nineteenth century the area around the Burlington Arcade was a predominantly male zone. Bond Street was the site of dandyism and male fashion. Many bachelors lived in this area, in hotels and chambers, such as the Albany running parallel to the arcade. They spent their leisure time engaged largely in drinking and gambling in the exclusively male clubs, such as Brooks's and White's, in the surrounding area. Not surprisingly, as part of the entertainment services provided for its male population, the area was renowned for its high class brothels and the streets of Pall Mall, St. James's, Piccadilly and the Haymarket formed a notorious circuit for street walkers.

The Burlington Arcade was closely associated with prostitution, especially the millinery shops. As long as the Beadles could be persuaded or bribed, its covered promenade was the perfect place for prostitutes to pick up rich clients, and in the winter arrangements were made to use the rooms above the shop units. These upper storey living quarters were each individually connected with their ground floor retail units via separate staircases, allowing these spaces to be used for part-time prostitution by the shopgirls themselves. The glazed shop windows provided a perfect view of the shop-girls and created a setting for images of "professional beauties" concealed in tobacconists' snuff boxes and print shop displays. As a result, shopgirls and shoppers alike were often considered to be prostitutes.

The way in which the women who occupied the arcades were conflated with the figure of the prostitute is pivotal to this discussion of gender and space in the Burlington Arcade. The display and consumption of women as visual and sexual commodities within the Burlington Arcade underscores the way in which architecture is gendered. It suggests that if we are to fully understand architecture, then we must consider its use and experience, and that to do this a feminist perspective is urgently required.

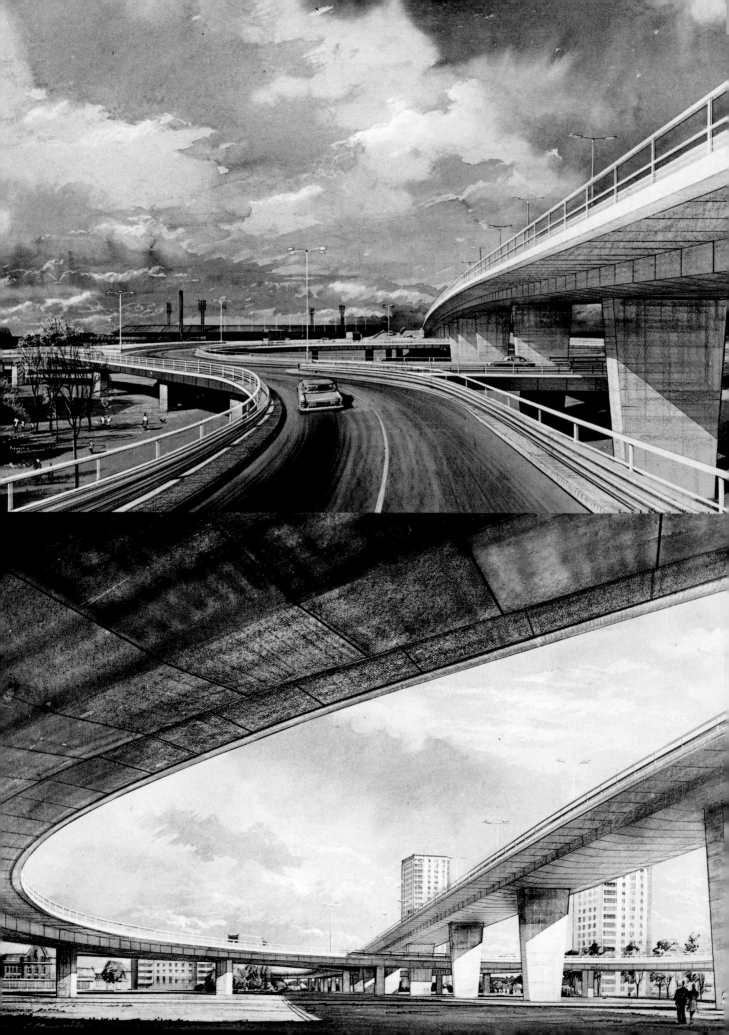

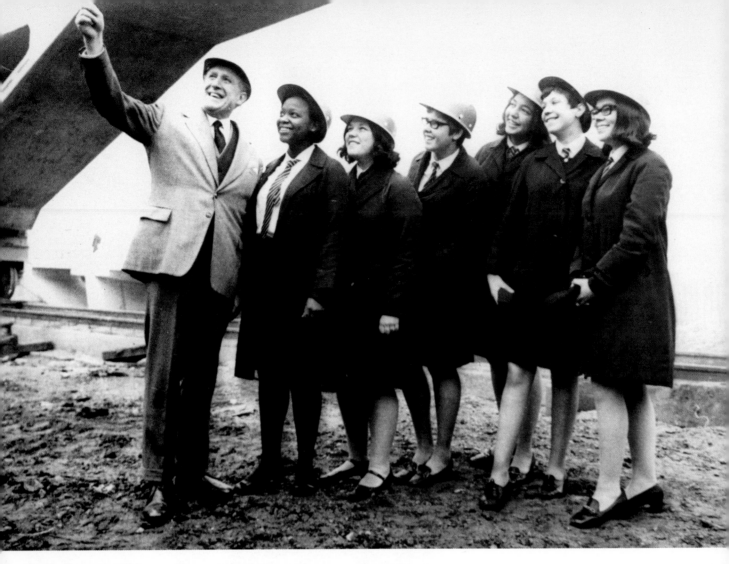

WESTWAY

Snaking through the inner city area of North Kensington, the Westway is possibly London's most dramatic work of engineering. Employing advanced technology, Britain's longest elevated motorway was the most significant achievement of the Greater London Council's (GLC) highways programme. Their publicists promoted the scheme optimistically, particularly as a twenty year programme of motorways was planned for London: the Ringways. This success story could run and run.

In 1968 Prince Charles visited the site, and the project's engineer was the subject of a television documentary. The previous year Desmond Plummer, the GLC Leader, had posed ebulliently with a group of visiting schoolgirls. Usually, GLC publicity featured the social groupings that were benefiting directly from new schemes; nuclear families on housing estates, the elderly in day centres, for example. However, the girls at the Westway were clearly too young to drive. They were there to suggest the future, for this was a project of social change. Indeed the Ringway proposals were largely antithetical to stable society. They were about movement and freedom, and, in particular, the personal freedom offered through private consumption.

When plans for the Westway were first published in 1951, the Ministry of Transport tended to see roads as a rural problem; cities were comparatively well served by public transport links. Indeed, communication had always been the basis of cities, initially as a matter of proximity. But during the nineteenth century railways enabled cities to expand, and London emerged as the world's first metropolis. Modern urban life, with millions of people circulating in a maelstrom of exchange, was radically different to that of the village. Modernism celebrated the freedom offered by this anonymity. Cities, mobility and a new level of personal freedom came to be seen as inseparable.

The high priest of modernist architecture, Le Corbusier, sought to enhance the urban experience by speeding up the city, proposing urban motorways in the 1920s. And this extreme social environment arrived in Britain with the first rural motorways built in the 1950s. Driving on them, unwelcome social interaction was not just unlikely, it was largely impossible. You had to follow everyone else, but the sense of freedom from them was unique.

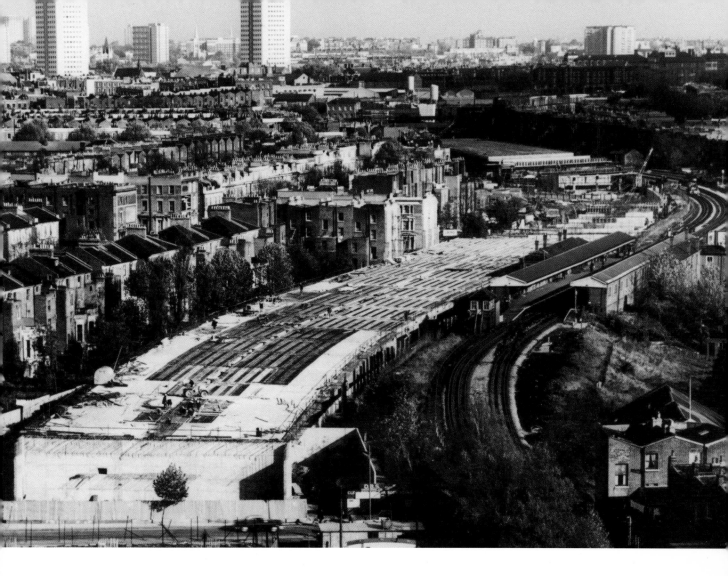

CAUGHT IN THE SPEED TRAP
SANDY McCREERY

The economic logic was to increase profit accumulation through faster rates of inter-city circulation. But around 1960 the Ministry of Transport changed strategy. New roads, it was realised, not only encouraged exchange, but were also important sites of consumption in themselves. Britain was the world's second largest producer of motor vehicles, and as export competition hardened the home market was increasingly important. If cars were to be sold to city dwellers they had to be given the space to use them. Urban motorways were now on the government's agenda. In 1961 funding was finally approved for the Westway.

But in the city, contradictions inherent to capitalism were graphically exposed through the motorway proposals. The tensions between public and private, social responsibility and anonymous freedom, community stability and personal mobility, exploded into a minor revolution in North Kensington. The Westway was not the political triumph intended; a carefully nurtured local success story became a global humiliation. For the road builders had run into a neighbourhood that sought social recognition before freedom from society, that valued sleeping, breathing and playing before cars, and that put communal amenity before private privilege. It also grasped the one potential benefit of the Westway: public visibility.

In the language of the time, North Kensington was a "twilight area". Only half its households had a bathroom, less than 10% a car, and the majority rented from private landlords. After the 1957 Rent Act de-controlled new tenancies, unscrupulous landlords in the area, such as Peter Rachmann, pressurised tenants to vacate in order to re-let at higher rents. In response, several tenants associations were formed which gradually developed into two highly politicised community groups, one chaired by George Clarke, the other by John O'Malley.

Clarke and O'Malley began to actively resist the motorway when it emerged that, despite the glossy images of spacious green parks, the builders were constructing commuter car parks beneath the carriageway, on land already used informally as a children's play space. Their groups were able to legally challenge further work after discovering that the Council had not sought planning permission from itself. Construction was delayed for six expensive weeks, until the Council capitulated, accepting that the space be put to community use. Without these actions, public amenities such as Portobello Green covered market and the Westway Sports Centre would not exist today.

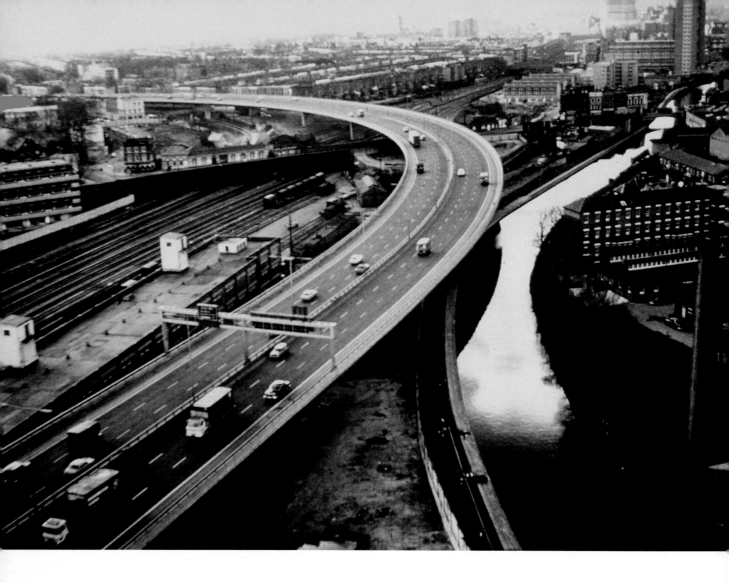

Their most spectacular triumph, however, was delivered at the opening ceremony. Television viewers as far afield as Australia saw the official cavalcade ridiculed with a barrage of insults. Later over a hundred demonstrators fooled police by driving up the exit slip road and along the wrong side of the carriageway to the ceremonial ribbon. They left after reassurances from Michael Heseltine that the Ministry of Transport would visit their homes to re-assess the impact of the Westway. Two weeks later, having heard nothing, the protestors were back, parading along the hard shoulder, and holding up the traffic. Four demonstrators were charged with causing obstruction, but the court sympathetically imposed nominal fines of £1.

Indeed, sympathy became almost the official line on the Westway. Just before the ribbon-cutting, the dignitaries attended a public meeting where speaker after speaker apologised for the suffering imposed upon North Kensington. The Transport Minister hoped that "those who use this road will spare a thought for those for whom it is not a blessing". The following day, all the serious newspapers carried leaders on the Westway, and all appeared to share a collective guilt. Just why had planners and politicians chosen to subject these people to environmental devastation, rather than ensure they had the most basic amenities? *The Times* concluded that it was "a bad advertisement for the GLC's controversial programme of urban motorways".

In terms of publicity, Clarke and O'Malley were the victors. Their actions helped spark a widespread revulsion towards modernist urban motorways. Of the proposed Ringways, only the M25 skirting London has been built. Although a government enquiry favoured the "Box" (the inner Ringway) a new Greater London Council was elected in 1973 largely on its promise to abandon the proposals. The connecting slip roads to the Box still hang aimlessly off one end of the Westway. Community had slowed a particularly private mobility.

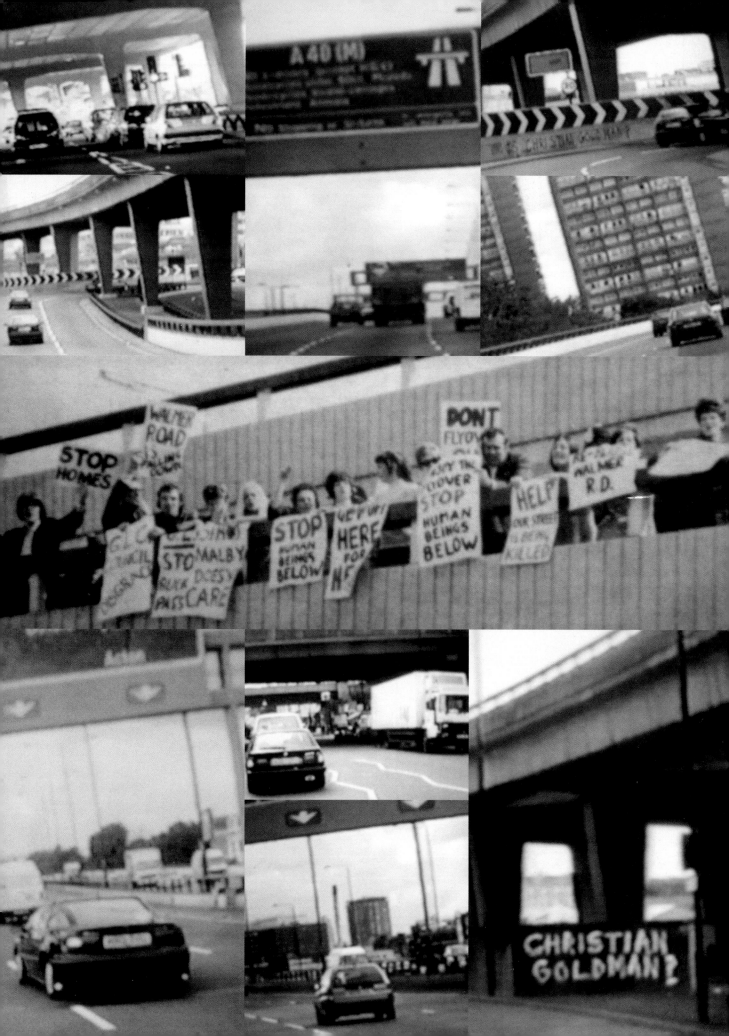

VENICE
METRO

BARRY CURTIS

RICORDO
di VENEZIA

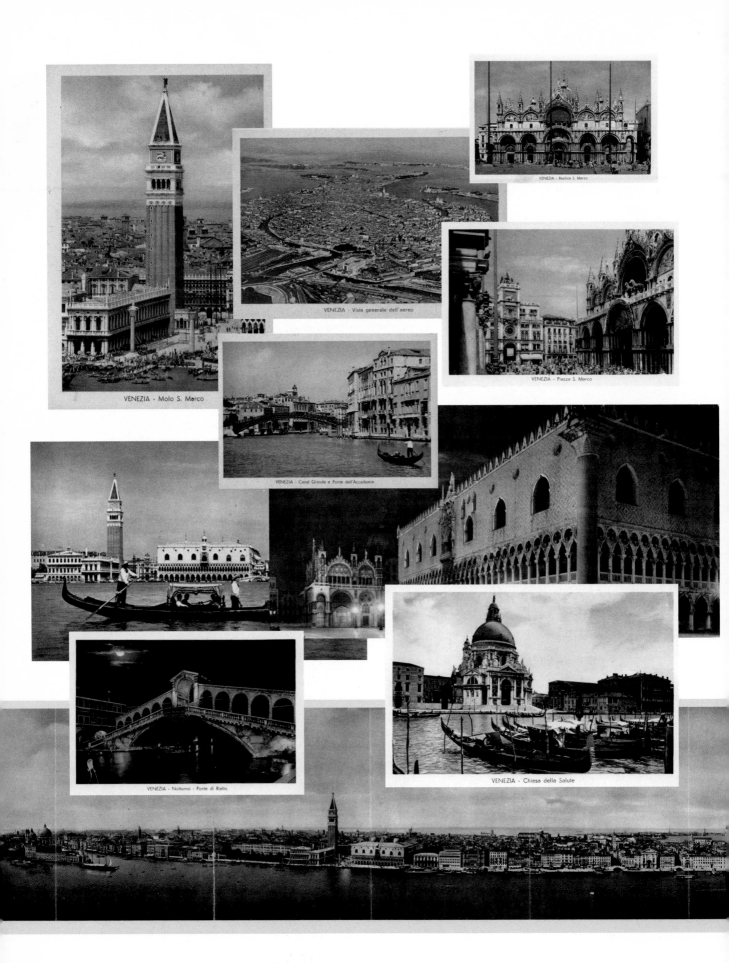

VENEZIA - Basilica S. Marco

VENEZIA - Vista generale dall'aereo

VENEZIA - Piazza S. Marco

VENEZIA - Molo S. Marco

VENEZIA - Canal Grande e Ponte dell'Accademia

VENEZIA - Notturno - Ponte di Rialto

VENEZIA - Chiesa della Salute

The Venice Metro project, which inspired this piece, was part of an ambitious architectural plan for Expo 2000. However, Venice's candidacy for this event was prematurely withdrawn by the Italian Government. The Metro project is characteristic of periodic attempts in Venice to attract investment and provide a more broadly based economy in order to increase the city's independence and remedy the waning population. Technological enthusiasms are now focused on a marine barrier and gentler adaptive and ecological solutions; the economic problems persist.

One day in November, I watched three men, in a rocking boat, manoeuvring a Bosch dishwasher through the third storey lancet window of a house in the Ghetto. Behind the Fenice, as the audience was leaving, I read a manifesto, pasted to a wall and signed by "Punx Venezia" demanding an antidote to the passé-ism of life in Venice.

That evening, I crossed the Grand Canal by gondola, standing shoulder to shoulder with commuters carrying briefcases.

Venice is the "other" of rational and hygienic space. A city in which little gets built, but a great deal of thought about building takes place. It is an urban museum which has provoked an extraordinary range of imaginary alternatives – "possible Venices" as one recent exhibition put it. It is the exception that proves the rule – a premodernist city whose appeal is the obligatory drift and dream which is the repressed of the everyday urban experience of twentieth century life.

An early testimony to closure and the fixity of what was already built, is the genre of "capriccio". Capricci are icons of the tourist sensibility – they juxtapose and montage architectural sites as in multi-view postcards, concentrating the components of the scene which are richest in historical and narrative significance. Compression involves excising empty space and the time taken to traverse it. The capriccio is a Metro of the imagination.

Venice is no stranger to the disruptions of modernity – Napoleon filled canals and razed churches, it was bombed in 1848, and again in the Great War and joined by road and rail to the mainland. Mussolini, trying to restore Venice's status as a major port and cultural centre, stimulated cultural tourism and provoked ecological disaster.

On investigation, the recent Metro project, put forward in the 1980s, with a plan for a

millennium Exposition, is a revival. In the nineteenth century, when Venice was a major industrial city, there were plans for a foot-tunnel and underwater traction for ferries between Venice and Giudecca. An underpass was mooted at the present site of the Accademia Bridge. In 1919 a subway train was planned to connect Venice to the mainland and various strategies were adopted to provide transport by road and rail between Venice and Mestre.

In spite of a history, hidden from guide books, of unrelenting dialectic between conservation and modernisation, Venice is a case of arrested development which has provoked tourism on a massive scale. The looming conundrum is – when does a city's commercial exploitation of its past vitiate its future? Is Venice now a black hole, whose historic gravity is prejudicial to the emergence of everyday life?

Various solutions have been proposed to stem the seemingly endless escalation of tourists, including the intermittent closing of the causeway and the quizzing of visitors. The metro solution, of laying a grid below the labyrinth may be one of the least disruptive to Venice.

The awesome problem of balancing the claims of the dwindling population against those of visitors, and the emotional consequences of living among ruins, are aggravated as decisions about what is worth preserving become more contested. In one respect, at least, Venice is in the vanguard – in generating an imaginative variety of solutions to the problem.

What is so oxymoronic about the Venice Metro, is its juxtaposition of the double texture identified as the subjective characteristic of all urban space by theorists like De Certeau and practitioners like Debord: the labyrinthine, on one hand and the rational, on the other.

The picturesque shock, experienced by many visitors to Venice when forced to transform maps into experience, corresponds to the uncanny effect of disorientation identified by Freud and codified by Anthony Vidler. This uncanny resides, also, in a resistance to progress. In its most immediate manifestation, it is a lack of clarity and purpose, the nightmare of encrustation and irrelevance that Modernism sought to deliver us from. In an other, it is that immersion in the past which has so frustrated Futurists and punks. The Metro is both the most rational solution to the problem of getting lost in history – an antidote to the "derive" and a metaphor for the fully technologised environment of the future.

The uncanny is a mood closely associated
with dreams and the unconscious. It is experi-
enced on an axis of reversible time, where
distant past and imaginary futures coincide.
It also mediates reversible co-ordinates of
space, of inside and outside, of above and
below. Napoleon's attribution of "drawing
room" status to St. Mark's square expresses
the experience of interiority which visitors
often associate with the urban fabric of Venice.
Where sky and water are mutually reflective,
inversions of light often occur, and, as
Adrian Stokes has noted, the buildings often
appear upside down. The Metro constitutes
another such inversion – a superego
undermining the id.

Venice has characteristically been described
in terms of regression and dreams. Originating
in the sheer audacity of building on and
among circulating waterways, the Venice of
tourism is an immemorial city whose history
supposedly ended when Napoleon took
possession. Tourists realise it as a totality,
but also in fractalised form as a capriccio of
fragments and patina.

At the moment, with ecology and conservation
in the ascendancy, and mindful of the spectre
of EuroDisney – the Metro faction is in retreat.
Plans for Expo 2000 have been shelved.
Times may change – the resumption of the
Veneto's role as mediator between East
and West awaits a settlement in the Balkans.
One day the Metro might be the best solution
as a surreally repressed rationality at the
service of commuters. In some future, Venice
may be preserved at the expense of the
capricious raids of subterrestrial tourists.

the power of place:
urban landscapes as public history
dolores hayden

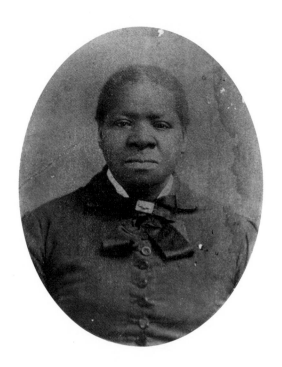

*The power of place – the power of ordinary urban landscapes to nurture citizens'
public memory, to encompass shared time in the form of shared territory –
remains untapped for most working people's neighborhoods in most cities, and
for most ethnic history and women's history. The sense of civic identity that shared
history can convey is missing. And even bitter experiences and fights communities
have lost need to be remembered – so as not to diminish their importance.*

*To reverse the neglect of physical resources important to women's history and
ethnic history is not a simple process, especially if we are to be true to the insights
of a broad, inclusive social history encompassing gender, race and class. Restoring
significant shared meanings for many neglected urban places first involves claim-
ing the entire urban cultural landscape as an important part of history, not just
its architectural monuments. This means emphasizing the buildings types – such
as tenement, factory, union hall, or church – that have housed working people's
everyday lives. Second, it involves finding creative ways to interpret modest
buildings as part of the flow of contemporary city life. A politically conscious
approach to urban preservation must go beyond the techniques of traditional
architectural preservation (making preserved structures into museums or attrac-
tive commercial real estate) to reach broader audiences. It must emphasize pub-
lic processes and public memory. This will involve reconsidering strategies for the
representation of women's history and ethnic history in public places, as well as
for the preservation of places themselves.*

*Some of the possible projects to emphasize gender and ethnic diversity
include: identifying landmarks of women's history and ethnic history not yet seen
as cultural resources; creating more balanced interpretations of existing land-
marks to emphasize the diversity of the city; and recruiting nationally known
artists and designers to collaborate with historians and planners to create new
works of art celebrating women's history and ethnic history in public places.
Often the subject of working women of color will draw the largest possible audi-
ence; in Los Angeles, for example, they are a majority of citizens but have long
been neglected as a subject for public history.*

left: detail of HOME/Stead: a rubbing from Evergreen Cemetery (top); Biddy Mason (middle); detail of HOME/Stead: the mark of Biddy Mason (bottom).

The first public art project undertaken by The Power of Place took place in Los Angeles and focused on Biddy Mason. Mason was born in 1818 in the South and lived as the slave of a Mormon master in Mississippi who decided to take his entire household west to Salt Lake City, Utah and then on to the Mormon outpost of San Bernardino, California. Biddy Mason literally walked across the country behind her master's wagon train, herding the livestock and caring for her own three young daughters. She went to court to win freedom for herself and her master's other slaves in Los Angeles in 1855. After the trial in 1856 she settled in the city to earn a living as a midwife. Her urban homestead, purchased with ten years' earnings, eventually included a two-storey brick building, which provided a place for her grandsons' business enterprises as well as for the founding of the First African Methodist Episcopal Church (FAME).

When I first saw the site of Mason's homestead, it was a parking lot in Downtown Los Angeles between 3rd and 4th Streets, Spring and Broadway – an unlikely place for a history project. But a new building was being erected on the site, and the Los Angeles

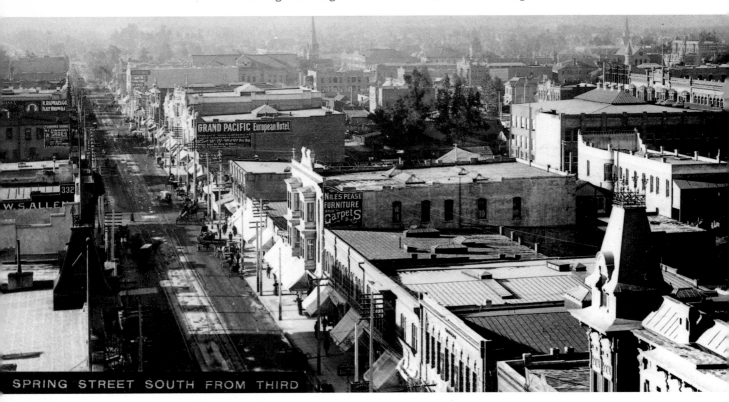

SPRING STREET SOUTH FROM THIRD

Community Redevelopment Agency (a city agency) was interested in some commemoration. I served as the project director as well as historian on the team, which included graphic designer Sheila de Bretteville, artists Betye Saar and Susan King, and curator Donna Graves. The first public event was a workshop in 1987 where historians, planners, community members, students and the project team members discussed the importance of the history of the African-American community in Los Angeles and women's history within it. Mason's role as a midwife and founder of the FAME church were stressed. Eventually, the Biddy Mason project included five parts. First, Betye Saar's assemblage, "Biddy Mason's House of the Open Hand", was installed in the elevator lobby. It includes motifs from vernacular building of the 1880s as well as a tribute to Mason's life. Second, Susan King's large format letterpress book, *HOME/Stead*, was published in an edition of 35. King incorporated rubbings from the Evergreen Cemetery in Boyle Heights where Mason is buried. These included vines, leaves and an image

of the gate of heaven. The book weaves together historical text with King's meditations on the homestead becoming a ten-story building. Third, an inexpensive poster, "Grandma Mason's Place: a Midwife's Homestead", was designed by Sheila de Bretteville. Historical text I wrote for the poster included midwives' folk remedies. Fourth, "Biddy Mason: Time and Place", a black poured concrete wall with slate and granite inset panels, designed by Sheila de Bretteville, chronicles the story of Biddy Mason and her life. The wall includes a midwife's bag, scissors, and spools of thread debossed into the concrete. De Bretteville also included a picket fence around the homestead, agave leaves, and wagon wheels representing Mason's walk to freedom from Mississippi to California. Both her "Freedom Papers" and the deed to her homestead are among the historic documents and photographs bonded to granite panels. And fifth, my article, "Biddy Mason's Los Angeles, 1856-1891", appeared in *California History*, Fall 1989.

The various pieces share some common imagery: gravestone rubbings in the book and carved letters in the wall; a picket fence, a

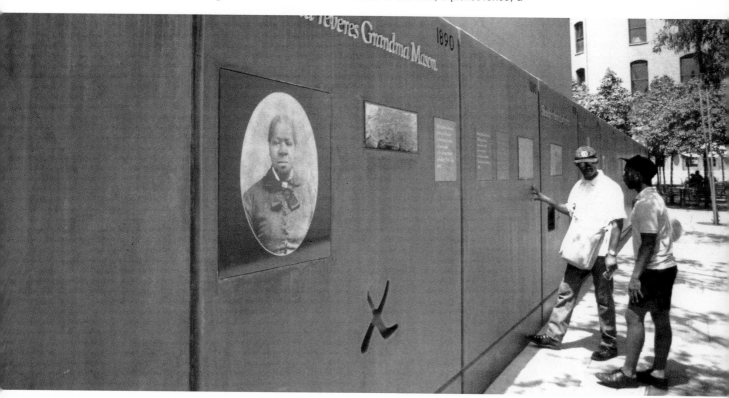

medicine bottle and a midwife's bag in the lobby and the wall. One old photograph of Mason and her kin on the porch of the Owens family's house appears in four of the five pieces, as does the portrait.

Everyone who gets involved in a public history or public art project hopes for an expanded audience, beyond the classroom or the museum. The wall by de Bretteville, finished in 1989, has been especially successful in evoking the community spirit of claiming the place. Youngsters run their hands along the wagon wheels, elderly people decipher the historic maps and the Freedom Papers. People of all ages ask their friends to pose for snapshots in front of their favorite parts of the wall.

Excerpted from Dolores Hayden, The Power of Place: Urban Landscapes as Public History, (MIT Press, 1995).

above left: Los Angeles, Spring Street looking South from Third Street, 1900. Biddy Mason's building is at lower right centre, two storeys high, below "Niles Pease Furniture and Carpets" sign.
above: Overview of *Biddy Mason: Time and Place*, 1989, by Sheila Levrant de Bretteville with The Power of Place, showing portrait of Mason, her Mark (X), and an 1890s view of city.

NAPLES:
THE EMERGENT
ARCHAIC
IAIN CHAMBERS

WRITING IN 1924 WALTER BENJAMIN AND ASJA LACIS NOTED THAT NAPLES CONSISTS IN A "POROUS ARCHITECTURE". FOR ITS PRINCIPAL BUILDING MATERIAL IS THE YELLOW "TUFO": VOLCANIC MATTER EMERGING OUT OF THE MARITIME DEPTHS AND SOLIDIFYING ON CONTACT WITH SEA WATER. TRANSFORMED INTO HABITATION, THIS POROUS ROCK RETURNS BUILDINGS TO THE DAMPNESS OF ITS ORIGINS. IN THIS DRAMATIC ENCOUNTER WITH ARCHAIC ELEMENTS (EARTH, AIR, FIRE AND WATER), WITH HUMAN PROJECTIONS (BUILDINGS, ARCHITECTURE AND CITIES), THERE ALREADY LIES THE INCALCULABLE EXTREMES THAT COORDINATE THE NEAPOLITAN QUOTIDIAN. THE CRUMBLING TUFO, CHILD OF THE VIOLENT MARRIAGE BETWEEN VOLCANO AND SEA, IS SYMPTOMATIC OF THE UNSTABLE EDIFICE THAT IS THE CITY. TO BORROW FROM THE BOOK (URSPRUNG DES DEUTSCHEN TRAUERSPIELS, 1928) BENJAMIN WROTE ON THE GERMAN BAROQUE THEATRE OF MOURNING WHILE ON CAPRI AND REGULARLY VISITING NAPLES, THE CITY IS AN ALLEGORY OF THE PRECARIOUS FORCES OF MODERNITY, A PERPETUAL NEGATION OF THE ASSUMED INEVITABILITY OF "PROGRESS", A CONTINUAL INTERROGATION OF ITS FOUNDATIONS. LIVED AS A "CRISIS" ENVIRONMENT, RATHER THAN A PLANNED ONE, NAPLES REMAINS A BAROQUE CITY. ITS INNUMERABLE SEVENTEENTH CENTURY BUILDINGS ARE SILENT WITNESSES TO THE CONTINUING DISRUPTION OF LINEAR DEVELOPMENT AS URBAN AND ARCHITECTURAL DESIGN DISSOLVE INTO SOUNDS, STREETS AND BODIES THAT DO NOT READILY BEND TO THE MODERN WILL. THE CITY OFFERS THE HETEROTOPIC SPACE OF VARIOUS PASTS, MULTIPLE PRESENTS . . . AND DIVERSE FUTURES.

Walking in the city, I follow narrow alleys that turn inward towards the piazza, a church, or bring me to monuments to mortality and disaster – the decorated columns that commemorate volcanic eruptions, earthquakes and plagues; only rarely do streets direct me towards the opening of the sea. It is as though the city draws its energies from the darkness, the shadows, sucking the light out of things in an irrepressible self-reflection that serves to illuminate its egocentricity. The sea seems an accessory, an appendage from which the fish once arrived and urban effluence is now dispatched.

Naples is also a vertical city. Social classes begin with one-room dwellings on the street – *i bassi* – to arrive at the attics and terraces of the professional classes and splinters of aristocracy still clinging to the heights. The sea and sky are caught in snatches, the lateral (democratic?) view is rarely permitted; the gaze is either bounded by narrow streets and walls or else directed upwards towards the secular and religious authority. It is an urban space that rapidly becomes an

Probably the aspect that most immediately strikes a visitor, a stranger, is that Naples is a city that exists above all in the conundrum of noise. Added to the constant murmur that a local *intellighenzia* spins in literary and critical conversation around urban ruin, nostalgia and decay, are sounds that rise from the street between the interminable acceleration of scooters and angry horns: the shouts of the fishmonger; the cries of greeting; the passing trucks and the megaphoned voices offering water melons, children's toys, glassware and pirate cassettes of Neapolitan song; the fruit seller who publicly comments on his wares and their low prices in the third person: "Che belle pesche. Duemila lire . . . ma questo è pazzo" ("What fine peaches. Only two thousand lire . . . but this guy's mad"); the itinerant seller of wild berries at seven in the July morning whose high cry fills the empty alley. These lacerations of silence attest to the physical punctuation of space by the voice, the body. It is the body that provides a fundamental gestural grammar in which hands become interrogative breaks, arms tormented signals and faces contorted masks. A pre-linguistic economy erupts in urban space to reveal amongst the sounds a deep-seated scepticism towards words, their promise of explanation and their custody of reason.

The hidden plan of the city lies in an architecture of introspection that is revealed not only in crumbling edifices and grime-coated facades, but also in the taciturn faces and sceptical sentiments of its inhabitants. Here, where the linearity of time spirals out into diverse tempos, the residual, the archaic and the pre-modern can become emergent, as visceral details and distortions undermine the dreamed-of purity of rational planning and functional architecture. In its art of getting by (*arrangiarsi*), making do, and re-arranging available elements as props for an unstable urban existence, the presence of Naples on the edge of Europe proposes an eternal return to the enigmatic lexicon of the city, to the contingencies of an unstable language in which all city dwellers are formed and cast. So, Naples is perhaps a potential paradigm of a city *after* modernity. Connected in its uneven rhythms and volatile habits to other non-occidental cities and an emerging metropolitan globality, it proposes an *interruption* in our inherited understanding of urban life, architecture and planning. Participating in progress without being fully absorbed in its agenda, Naples as a hybrid city reintroduces the uneven and the unplanned; the contingent, the historical. Viewed and above all lived in this manner, the interrogation posed by Naples returns the question of the city to the relationship between politics and poetics in determining our sense of the ethical and aesthetical, our sense of the possible.

jonathan charley

sentences upon architecture

the disintegration of everything familiar

It really could have happened to anyone. For him it had started with no more than a blind drunk gaze into popular images of terminal space-time compression and urban decay. As the chorus of inmates reminded him, the only hope was to search for a way out of the predicament and to find something better. But this had always begged two questions – was there a real world that could be known outside of this pervasive advertisement and in what sense could it be improved upon? It was definitely time to go back to school.

imperialism

The following sentences are probes into the development of universal places and spaces, parallel built environments that can emerge anywhere on the planet where capitalist social relations take root. The emergence of formal and spatial characteristics within our cities are signals of global economic and technological integration, a process that carries with it not only similar ways of organising the production of buildings but of appropriating the experience of them.

estrangement

INDUSTRY

Dragged from the primitive commune and sold into slavery, history's vagabonds take the first steps. Wrenched from the land during the feudal period, they eventually come to rest on the machine, estranged from each other, from the means and ends of their production, and from nature.

wages

All the historic struggles over land and bread were rehearsals for this first and final act of the modern when in all but a few remote corners of the planet, every human subject had become a wage worker, and every fragment of social life had become an arena for capital.

profits

Despite our desire for autonomy and freedom, the production of the built environment for most of its modern history never manages more than two steps away from the process of capital accumulation.

the architectural commodity

Land, buildings, materials, knowledge, human labour and space all assume the form of the commodity. Thereafter, the production of the built environment can never escape the logic that comes from the unity of mathematical law and exchange value, such that the relation of necessity to the realm of freedom remains purely quantitative and mechanical.

capitalist utopias

The production of the architectural commodity in the shape of ideal vernaculars, parodies of luxury and historical triumphalism, lies at the centre of the construction of a culture based on myths of free markets, heroic individuals and patriotism. In this mythology, powerlessness and non-identity become represented as freedom and happiness.

THE MYTH

the architecture of stasis

The selling of capitalist utopias and unrecognisable representations of the social world becomes an intensive and necessary campaign so as to reserve the illusion that property relations have been fundamentally transformed in the interests of the majority. This is visible not only in the production of an architecture of stasis, but in the marketing of the image of the ideal home and model citizen.

boosterism

This has been accompanied by a new race between regions and cities to organise spectacular social rituals in order to attract more capital. Linked to an ancient process of civic boosterism that has precedents in the Olympian race to build Gothic cathedrals and Victorian Empire Cities, it has resulted in the contemporary metropolis competing not only to be a pivot in the circulation of global capital but centre of Culture, Festivals, and Historical Memory.

ideology

Such spectacles form part of a wider process of ideological production in which questions of capital, profit, rent, wages, of social and spatial inequalities remain camouflaged. Similarly, the making of architectural works become ideological acts through the obliteration of their social origins and through the concealment of the role architecture plays in the reproduction of capitalism.

ghosts

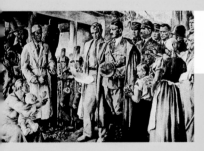

The texts and talk about architecture and the city increasingly take on the character of romantic painting, producing an image of the world in which labour becomes a ghost, poverty becomes transparent or dignified, and the suspension of basic democratic rights become touched out of the picture. In this alliance of politics and aesthetics the class origins of knowledge are hidden, and a violent conformity masquerades as universal liberty.

THE DEAD ZONE

space and labour

From the mills of nineteenth century Britain to the Ford car factories of the early twentieth century USA, and from the boulevards and barricades of Hausmann's Paris to the Imperial plan of Stalin's Moscow, it is clear that control of the labour process and of space is an essential pre-condition for the maintenance and reproduction of class societies.

uneven development

Two of the most significant features of this process in the built environment of the late twentieth century have been the destruction and privatisation of public urban space, and the development of zoning patterns that reflect the class and ethnic fragmentation of society. But the ghetto cannot be hidden, and we are left with a violent confrontation between Sunny Valley Housing Corporation and Shanty Town Inc., between the disintegration of Old Dystopias and the fragility of New World Disorders.

surveillance

Many of these new configurations of space operate under the supervision of private security forces and use both electronic tagging and video-camera surveillance to control access and monitor movement. In the suburbs, the neighbourhood watch and protective policing preserve the illusion of bliss as the fortified edge city becomes the focus of vote seekers.

imprisonment

We have arrived on the verge of the *carceral city*, a world of perpetual commodity production and consumption, a *panoptic society* of observation and discipline where the technologies of order and normalisation are physically and electronically integrated into social life.

architecture of the mirror

At the centre emerges a corporate architecture housing the bureaucracy. Such building has little to do with the postmodern promise of choice and diversity. We have instead an architecture of mirrored glass, fake marbles, and triumphant entrances, an architectural language that has been described as the *archisemiotics of class war*.

the architecture of status

Wild architectural ostentation is an old method of masking social conflict. It appears not only in the Berlin and Moscow of 1936, but in the whole archipelago of new institutional buildings that lubricate the movement of capital and fortify the state. In Britain we have recent additions such as the MI5 HQ in London and the DHSS HQ in Leeds, but examples can be seen all over the globe in the business districts that dominate the skylines of San Francisco, Brussels, Paris, São Paulo, Rotterdam, Frankfurt, Tokyo, and New York . . .

the dead zone

This is the architecture of the Dead Zone, the administrative fortress of governing bureaucracies. It is an architecture that is a symbol of the concentration and globalisation of capital, armouries of buildings that are in-human in mass and scale, wasteful of natural resources and which have adapted the techniques of exclusion and spatial hierarchy which can be found in all fortified citadels.

resistance

The traditional call for the democratic social ownership of land and of the means of building production, for the possibilities of free and creative self-determination, for gender and racial equality, and for non-administered space and time, become concepts so unnecessary as to make them alien. We should be on our guard that the surveillance city, which is one symbol of the institutionalisation of civil war, does not catch us unarmed, disinterested and incapable.

THE VISIBLE CITIES OF SÃO PAULO ELISABETTA ANDREOLI

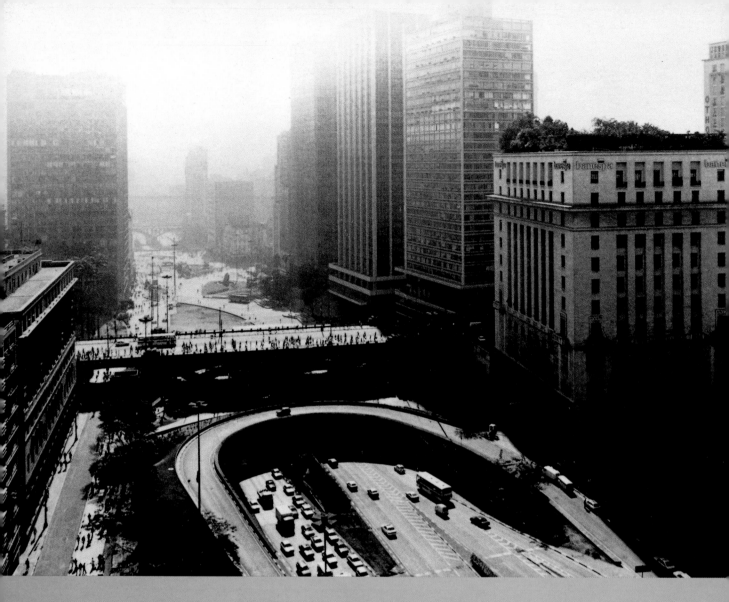

When we think of a city we first think about its look – the look of its buildings, streets and monuments. Or, we might recall the "flavour" of the city – the way people inhabit a London pub or a Parisian square. In either case, the built environment of the city is the most immediate clue to its identity.

The city of São Paulo escapes this mechanism.

São Paulo has a problematic relationship with architecture. Despite it being Brazil's economic and cultural capital – and one of the world's biggest metropoles – São Paulo does not have a strong specific image. The chaotic cityscape reveals odd juxtapositions of early twentieth century run-down mansions with prematurely aged modern buildings and postmodern pastiches. The city's representative monuments are few, and often their presence is concealed by daily activities and by new buildings. The numerous newspaper kiosks spread all over pedestrian pavements sell a variety of postcards, most of which show images of touristic Brazil: the Amazon, Rio de Janeiro, exotic regions and the North-East. It is hard to represent São Paulo's spatial and architectural merits; tourist brochures tend to stress São Paulo's rich cuisine and night-life as its main appetising dishes.

This is not to say that there are no places charged with symbolic meaning; for example, the Anhangabaú Valley is the historical nucleus of a city that in little more than half a century expanded to occupy a surface area of 900 square kilometres and become home to 15 million people.

To foreign eyes, the Anhangabaú Valley might appear rather chaotic, given the multiple flows of pedestrian and car circulation, the dramatic interaction of horizontal and vertical planes and the variety of architectural styles. And yet it bears the marks of its history: the French style of the Municipal Theatre evokes the 1920s when São Paulo was the capital of the coffee economy; the first skyscraper, showing a mixture of modern technology and Italianate fashion, celebrates the economic success of Italian immigrants; the American look of other buildings recalls the optimism of the 1950s, when Brazil switched into the idea of modernisation and economic development; and a postmodern look keeps the city apace with present times.

Despite its symbolic and historical relevance, this part of the city centre had been going through a process of urban decay since the 1960s. But in 1990, a new architectural project was implemented. Some of the narrow streets were closed to car circulation; and the whole Anhangabaú Valley was freed when the large and busy avenue running along it disappeared underground, and a vast space was given back to pedestrians, music shows and popular events. The idea was generous, especially in a city whose spatial development has so deeply and steadily been shaped by the needs of private transport and national economic policies (especially the car industry). The City Council was hoping to halt the decline of the city centre, caused partly by the emergence of peripheral urban poles and the enclosed territories of shopping centres. The project was an attempt to rescue and re-establish the city's memory and its identity. And yet, somehow it did not work. Or did it?

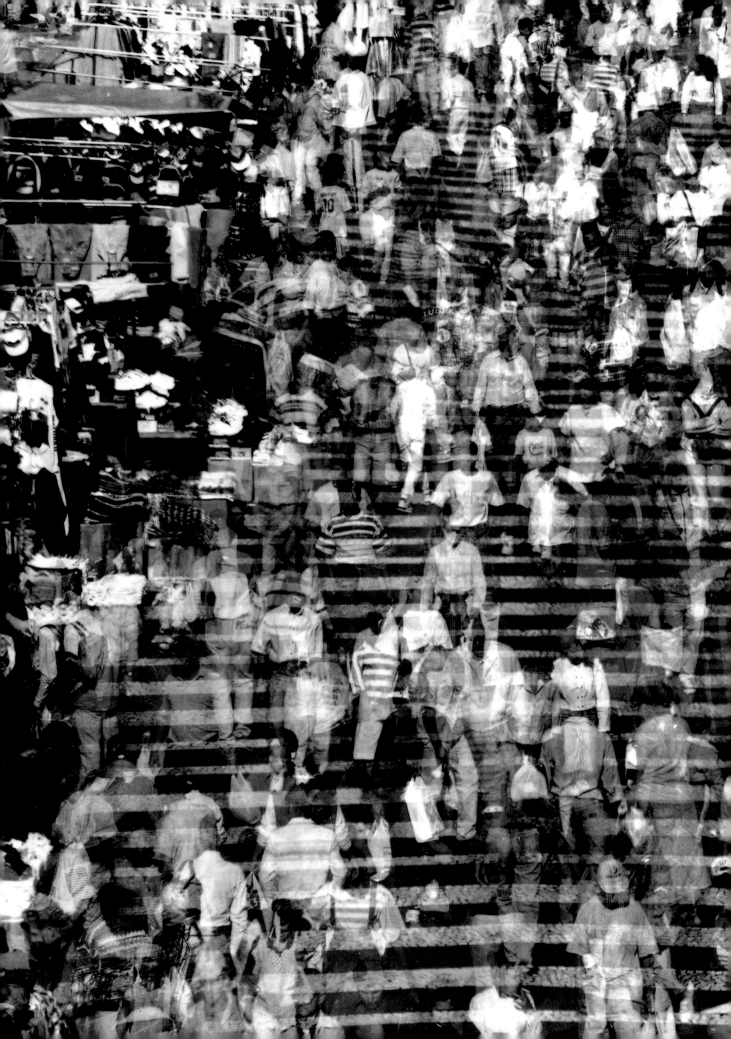

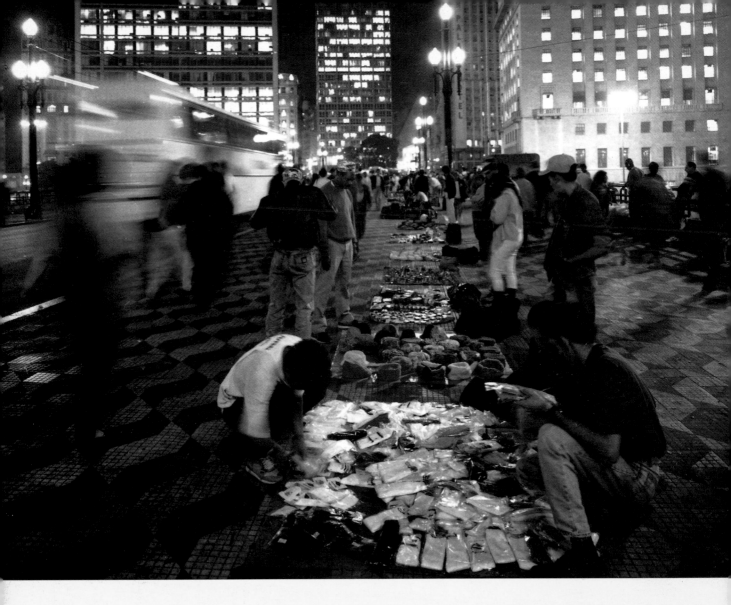

The coloured pavements, green areas and fountains of the newly developed Anhangabaú Valley lack sufficient strength to compete with the density of urban signs and human ebb and flow. The green areas have soon turned brown, dried out by the many footsteps of people attending public concerts and leisure events. A temporary metallic stage has become a permanent feature resting – and rusting – against the viaduct over the valley. On the whole, the project has neither constituted a new significant image of the city, nor has induced gentrification in the area. The centre remains tawdry, and the flow of people passing through it daily appears indifferent to the renewed environment. Nomadism seems to be the clue, and car-free streets are now seriously congested by a great tumult of people who find opportunities for all sorts of activities in central public areas.

In the early hours, hundreds trade goods – imported, smuggled or just obtained without the necessary tax documentation – on the pavement in front of closed shops. Improvised and short-lived kiosks sell hot drinks and cakes. When the shops open, these early traders yield to others selling the same products but with official licenses to trade. During the week, hoards of bank employees, businessmen and administrative staff populate the area while street-children try to get their bit out of passers-by. At the weekends, Nordestinos (immigrants from the north) turn the less noisy space into their own territory for specific trade or religious gatherings. Sharing, or rather competing, for the same space generates tensions and in the street police and even private guards make their presence felt.

The sense of multiplicity, characteristic of any metropolis, has always been particularly strong in São Paulo, given its numerous ethnic and cultural groups. São Paulo is a place where "anything can happen, everything can be seen". While other boroughs become more and more socially homogeneous, in the city centre the sense of multiplicity and contrast remains only too vivid – and sometimes violent. Here live many of those who have no jobs, homes or even families. Here come to trade those who live in the poor parts of the periphery. In São Paulo today, to be in the centre is to border the margins.

No-one would expect architecture to provide solutions for social and economic problems, especially those generated by 15 years of economic recession. But many would grant architecture the power to shape places and charge them with meaning. The older buildings along the Anhangabaú Valley stand as representative marks of dominant ideologies of previous epochs. Today, the urban intervention in the Anhangabaú Valley is weak, but paradoxically it allows the heterogeneity and complexity of a difficult – and yet exciting – city to rise up, with little mediation.

The project was presented as São Paulo's new postcard image. However, the urban and architectural look of the Anhangabaú Valley is not strong enough to become a significant icon of São Paulo. Rather, it remains an ideological territory to be occupied, an open space of negotiation. The notion of centre and periphery collapses, reminding us of the problematic relationship between the real city – any real city – and the idealized one.

ELECTED BY THE PROPERTY OWNERS: REDEFINING CITY GOVERNMENT IN MID-TOWN MANHATTAN

WILLIAM MENKING

"THERE ARE
THOSE WHO
QUESTION
THE CLOUT
YOU WIELD
AS HEAD
OF THESE
DISTRICTS.
THEY ASK,
WHO ELECTED
YOU? I WAS
IN EFFECT
ELECTED
BY THE
PROPERTY
OWNERS
AND
TENANTS
WHOSE
MONEY
THIS IS.
THIS IS
NOT TAX
MONEY.
THIS IS
PRIVATE
MONEY.
THE PROPERTY
OWNERS
AND TENANTS
DECIDE HOW
THEY WILL
SPEND
THEIR MONEY.
THE ESSENCE
OF THE
PROGRAM IS . . .
TO HAVE
THIS MONEY . . .
TARGETED
TO THE
NEIGHBORHOOD
OF THE
PEOPLE WHO
CONTRIBUTED."

DANIEL BIEDERMAN

Contemporary (re)inventors of government in America – many who scorn government and public sector planning – like to point to the Business Improvement District (BID) as a model of urban management and development. There are 1,000 BIDs in the United States with over 30 in New York City alone. In their domains they assume responsibility for architectural and urban design, planning, policing and social service delivery. Carried out in the name of the public good, these services primarily benefit their own spatial zone. They are directly contributing to the creation of a dual, two-tiered city, where affluent "improved" districts are clean, crime-free and well lit, while the remainder of the city is increasingly lacking in all of these essential services.

The current business-friendly government of New York, hoping to "downsize" government, will give property owners up to $60,000 in public money to plan a BID. The three largest and most important BIDs in New York City are the Grand Central Partnership, Bryant Park Restoration Corporation and the 34th Street Partnership, which are all controlled by a single management company. Its president, Daniel Biederman, has been called "The Mayor of Mid-Town" by the *New York Times* and he boasts he was "elected by the property owners".

These three districts together take up 95 city blocks and over 100 million square feet of commercial floor space. The Grand Central operating budget alone is nearly $7 million dollars per year. In addition BIDs are allowed to issue government guaranteed and tax exempt bonds to make physical improvements in their districts; Grand Central raised $56 million from issuing such bonds. Biederman claims these special assessments are an opportunity for the private sector, who would otherwise flee the city to pristine suburban campuses, to "contribute funds to public improvements and public services". The use of "contribute" here is clearly a euphemism, and on this question Biederman is uncharacteristically direct and honest. He claims that this funding is used to make the "environment better for business", thus increasing the value of the city's real estate, and improving commercial occupancy and sales. However, if it were paid into the general tax fund instead, this money would go to the government to provide services for the whole city.

What do BIDs do with this money? Biederman was quoted in the *New York Times*: "If you were the mayor of Paris, I'd be ashamed to show you this", a display of outrage directed at what he described as an example of urban tawdriness – the bright colors and garish signs on a hot dog cart sitting on a 43rd Street sidewalk! To purge the city of such offenses, Biederman's group hires architects and planning firms to suggest physical "revitalizations" for his districts. Thus Benjamin Thompson and Associates, designers of countless American "festival marketplaces", has been commissioned for America's most dynamic but unruly city. For 34th Street they have proposed a series of street furniture changes to "set a mood of celebration". For Greely Square, a park heavily used by the desperate homeless population, they proposed "distinctive paving, safe light levels, water, refreshments and entertainment designed to help attract 'Good Neighbours'".

Meanwhile, at Grand Central, Biederman is not only removing garish hot dog carts but undertaking a major urban design initiative, spending $32 million for new street lights and trees; replacing signs and signals with international symbols; and to cap it off a spectacular lighting of the famous terminal building. They have teams of formerly homeless people removing illegal flyers and graffiti, and employees who "monitor pornographic stores".

While they architecturally "improve" the streets of Mid-Town Manhattan, the BIDs are also taking control of the social life on those streets. They provide police and social service "outreach" for their areas. The Grand Central District alone employs 44 uniformed guards and 3 plainclothes investigators. Though not allowed (yet) to carry pistols these "para-police" are tied in by radio to the New York Police Department, and make official "citizens arrests". The officers, some of whom are retired or laid-off City Police, are only required to take a 35-hour course in criminal justice and spend two weeks training in the streets before they may begin patrolling. The guards make approximately $10 per hour or $21,000 a year, significantly less than City Police. In fact, the low wages of all BID street level workers allows BIDs to claim that they are more efficient than the city in providing services for their districts. By contrast, BID top officials are very well paid; Biederman earns $305,000 per year.

There is little dispute, however, that with the added police the BIDs are less crime ridden than the city at large. Biederman maintains that, between 1991 and 1992, reported crimes decreased in Grand Central by 16%, in Bryant Park by 22% and 34th Street by 9%. However, BIDs may simply be pushing criminals to other neighborhoods. More ominously, the BID in Times Square is allowed its own "Community Court", to handle what it calls "quality of life crimes". Graffiti artists, illegal peddlars and prostitutes, are sentenced to community service cleaning Times Square.

Surely the most controversial of the services offered (and hyped) by New York City BIDs are the "outreach" programs for the homeless population in their domains. Biederman boasts that "the streets are very clean and hundreds . . . have been moved out of homelessness". One program includes "The Bag Exchange", which offers homeless people financial vouchers for full trash bags that they bring, with which, as a BID executive boasts, they can "buy underwear". Another BID has introduced "banks" to help the homeless! These are actually architecturally designed trash receptacles where environmentally conscious citizens deposit empty bottles and cans for "anyone who wants to remove them and redeem them" for five cents.

In 1994 the Grand Central BID began paying homeless people – whom it labels "outreach workers"– $1 per hour "to visit sites where other homeless people gather and encourage them to visit the Partnership's drop-in center for a meal, counselling and job-training" which qualifies them to work for the BIDs street sweeping crews, again for $1 per hour. The BID was so pleased by its success in purging the homeless from its confines that it contracted with banks to provide "outreach workers" to persuade those living in Automatic Cash machines to leave. However, the BID was in fact paying homeless men to physically attack other homeless people to drive them out of the Grand Central area.

In fact, BIDs in New York City are beginning to act like independent governments. The Grand Central Partnership is wooing the Transit Police Union to relocate from 14th Street in downtown Manhattan to a building in their district. However East 14th is a particularly poor and somewhat troubled street, which wants a police headquarters in their area to discourage crime. If the sight of a wealthy BID competing with a poorer district is not troubling enough, as a resident of just such a distressed area I can personally testify that while Mid-Town Manhattan can now claim there are no "3-card monte" gambling games in their districts anymore, they have all relocated to my neighborhood.

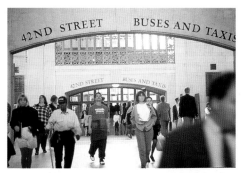

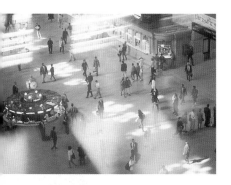

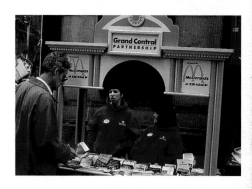

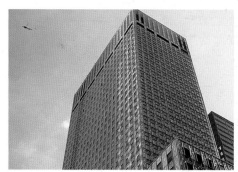
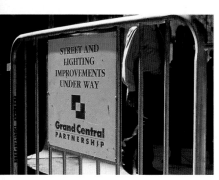

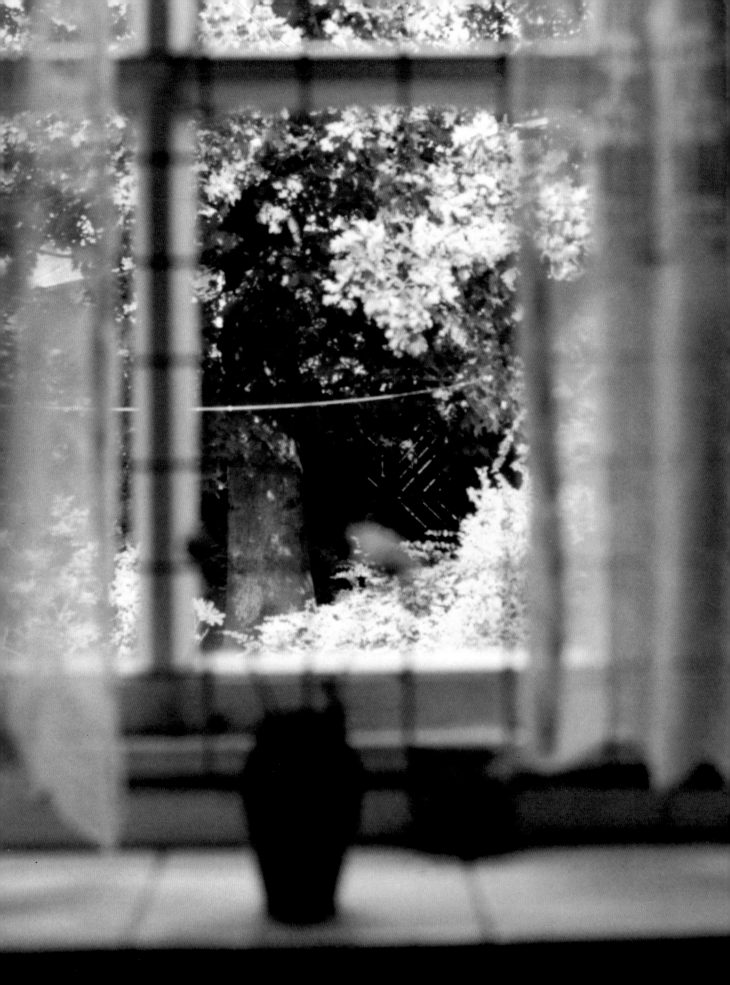

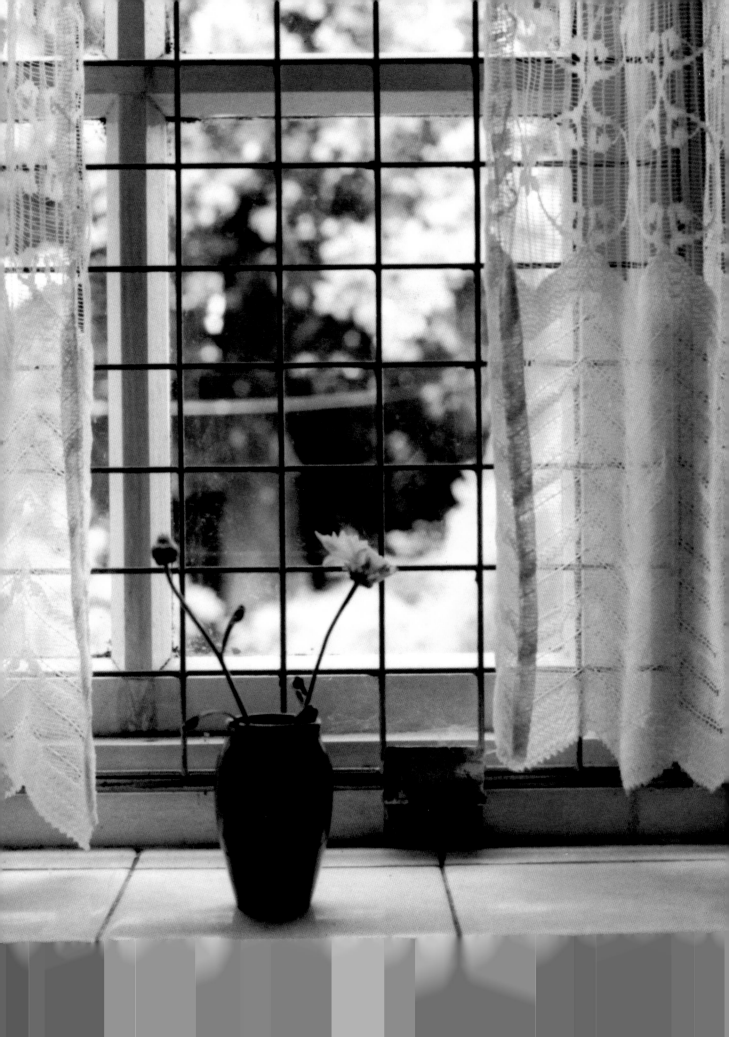

MY MOTHER LIVES NOW IN
A NURSING HOME

JUST ACROSS THE GREEN
FROM OUR HOUSE. IT
STANDS ON THE SPOT
WHERE ONCE MY SISTER
AND I WENT TO SCHOOL.
THE TURNING OF THE
GENERATIONS ON THE
ESTATE IS REFLECTED
QUITE PRECISELY IN ITS
BUILDINGS. FOR NEARLY
FIFTY YEARS MY PARENTS
HAVE LIVED ON THIS
CORNER, WATCHING
THESE CHANGES HAPPEN.
EVEN BEFORE THAT,
THEY WOULD COME
WALKING HERE ACROSS
THE FIELDS AND BETWEEN
THE FARM HOUSES THAT
MADE THIS A PLACE
BEFORE THE ESTATE WAS
BUILT. THEY SAW THE
BIRTH OF THE ESTATE.

It was the birth of a new social place. As Manchester needed space it looked south across the Mersey. There, the fields of Cheshire – health-giving, rural, spacious – basked in shocking contrast with the city's crowded slums. Social reformers, socialists, and garden-city planners dreamed of expansion. An official report spoke of "virgin land".

But no land is virgin land. The natives protested. Large landowners at first refused to sell. Local people objected. "Cheshire should be kept as Cheshire" said they – a refrain which only indicates a lack of argument. (And how often we hear that refrain.)

The battle was won by the socialists and planners, and the first municipal garden city – eventually to house 100,000 people – began to take shape: quality housing for working people, set amongst trees.

Those ideals were gradually lost. The 1950s race to build houses saw standards decline. And today a changing politics is once again re-casting the social meaning of this place. Many of the houses are now in private hands. The school we went to on that corner was a state school, but the nursing home there now is private. The move from school to nursing home reflects the wider history of the estate. The layers of memory are filtered through a changing politics. And every now and then a dreadful rumour brings the terror that the estate might be sold off into private hands.

When my parents were young, their lives were quite spatially confined. Walks across the Mersey to where the estate now is, bus-rides into town, holiday excursions to Llandudno: these probably marked the furthest reaches.

In middle life came visits to daughters who had moved away, came a car, came occasional brief holidays abroad. This corner, then, was a base-camp for a larger life.

Older age brings a closing-in again. The body imposes some limits. Infirmity closes down the spaces of my mother's life. Brief rides outside in a wheelchair on good days. The city maybe seems irrelevant when your attention is focused on pain. You can see the Pennines from here, they say: but my mother's eyes no longer reach that far.

Yet "the city" is more than what you see. There is an unseen city which can be felt, smelled, heard. There are local landscapes of sound and touch. The feel of a rabbit on the community farm, the smell of lavender in the grounds, the helping hand of Social Services. The planes at the now-expanded airport are heard now but not seen, as they fly over more spatially restricted lives. (The new generation goes to Florida for its holidays.) We need cities of sound and touch, cities which play to all the senses.

For my father, too, the spatiality of life has changed. No longer able to drive a car, bus passes are a blessing. But broken paving-stones mean you keep your eyes down as you walk. The body again.

Local spaces get re-worked from the planners' dream. Acts of appropriation by others may close down avenues of your spatiality. You put a grille over the back window. Vandalism (not new round here, but perhaps more threatening when you're old) warns you off. There are seats where you can no longer sit. Young lads on bikes can terrify the life out of you. My father has devised a spatial tactic: he never walks in the middle of the pavement but always to one side (the inside edge is best) – that way you know which side of you the bikes will go. (Again, the spaces of the city are utterly material.) The freedom of movement claimed by a bike on a pavement can encroach on the freedom of others. "The public" for whom this place was dreamt and built turns out to be multiple and differentiated – its various demands on space come into conflict. Maybe we could imagine urban design in terms of the geography of such differential spatial powers. The spatialities of our lives are many and constantly changing. We need cities which enable them all.

It has been written that "monumental space" offers "each member of society an image of that membership", that it constitutes "a collective mirror more faithful than any personal one" (Lefebvre). Maybe, maybe not. What *is* true is that many non-monumental – that is to say, quite ordinary – spaces hold up a mirror which *excludes* you from membership. The blank impenetrability of the security-blind on a once-well-used, but now closed, shop. The sprouting of places where you'd never go (though on this bit of the estate even the video shop has closed down).

Without hostility, but simply with the exuberance of the new, a place constructed by and for your generation gets taken over by another which you don't fully understand. As the built environment shifts to respond to other desires, the consequent exclusions may themselves be identity-forming: they, too, are part of what tells you who you are.

BUT MY PARENTS ARE NOT PASSIVE EITHER. SPACES AND PLACES CONTINUE TO BE MADE. THE LOCAL SPACES OF A WHEELCHAIR RIDE, OF A VISIT TO THE FARM. IN THE EVENINGS AS WE TALK, THE SPACES OF THE MEMORY OF LONGER JOURNEYS, OF THOSE VISITS ABROAD. MOST OF ALL THERE IS THAT SPACE WHICH IS HARDEST OF ALL TO PICTURE, TO PIN DOWN: THE SPACE OF SOCIAL RELATIONS. THE PEOPLE ON THE CORNER WATCH OUT FOR EACH OTHER. THE NEIGHBOURS MAKE SURE THAT MY FATHER'S CURTAINS ARE DRAWN TO EVERY NIGHT AND DRAWN BACK IN THE MORNING. THEY CHECK TO SEE THAT THE MILK'S BEEN TAKEN IN.

AND THE ESTATE IS STILL LOVELY. THE TREES WILL OUTLAST US ALL.

TWICE-TOLD STORIES: THE DOUBLE ERASURE OF

M. CHRISTINE BOYER

"There are eight million stories in the Naked City and this is just one of them." The Naked City, 1948.

The contemporary space of Times Square, once the popular entertainment district of vaudeville and the Broadway theater, the central space in which New Yorkers celebrated public events, is suffering from a series of Disneyfications and Theme Park simulations; it is controlled by urban designers who have planned its spontaneous unplannedness. How have we let this happen to one of the icons of American popular culture?

To explain this process we should perhaps examine the role that Times Square has held in the popular memory of the city, for we will find that a double gap has occurred in our memory devices – one in the late 1940s and another in contemporary times. These gaps enable a distinction to be made between realistic representations and simulated effects. It engenders a twice-told story that in separate versions lingers nostalgically over the memory of New York's Times Square, trying to keep it from change and destruction.

Narrating the story of disappearance. In postwar America when the first memory gap occurred, central places such as Times Square were beginning to be threatened with disappearance, they were no longer experienced directly by pedestrians but were retreating into abstraction. Abandoned for the suburbs, fragmented by urban renewal, and tormented by the automobile, the postwar American city was a place of discomfort and disorientation, a space that was increasingly unknown to the spectator. Important places in the city were reduced to representational images that could stand-in for places no longer explored directly or recognisable from the details of direct exposure.

A certain degree of command over these unknown terrains could be effected, however, by such devices as the detective story that offer an illusion of reality in narrated form; they focus, point out and re-member parts of the city that have been covered over by mysterious events. Thus the dark city of film noir not only played on the experience of loss and anxiety, but offered a set of mapping procedures that presented an imaginary centered and legible city, enabling the spectator to gain at least cognitive control over a place that was no longer experienced directly.

The semi-documentary The Naked City provides an excellent example of such "cognitive maps" not only because it stars the streets and landmarks of Manhattan as its main attraction, but the film also utilises voice-over narration in an unusual manner to enhance the story's factual base, and to ennoble its realistic narration by borrowing the authority that documentaries try to assume. This narrated story attempts to represent the city as it is, naked and objective as possible, and in this manner tries to save at least the memory of it from eradication and disappearance. The voice comes from another time and space than that of the film and thus as an overlay it can comment and draw together parts of the story. In The Naked City, the voice-over maps out the case history of police work and ties together the 107 different locations filmed in the streets of New York. And it maps out a city that once might have been well known by the audience, but now required a guide to link together its landmarks and places.

The film begins with with an aerial view of lower Manhattan that moves northward, as we hear:

"As you can see, we're flying over an island, a city, a particular city, and this is the story of a number of its people, and the story, also, of the city itself. It was not photo-graphed in a studio. Quite the contrary . . . the actors played out their roles on the streets, in the apartment houses, in the skyscrapers of New York itself . . .

This is the city as it is, hot summer pavements, the children at play, the buildings in their naked stone, the people without makeup."

The spectator is presented with the God's eye view of the city, stretched out below and waiting for inspection; this is a truthful story, the city as it is, the Naked City whose facts will be exposed, whose crimes will be revealed.

The voice-over seems to hold the same role as the film's many telephone exchanges and communication devices. They allow us to relate to disembodied voices which tie together, or map the city that is being threatened with dematerialization. So for example, as we close in on the chase, the Police Headquarters Radio Operator speaks into the microphone "Emergency . . . all squad cars on the East Side of 14th Street to the Williamsburg Bridge, from 1st Street to 5th Avenue, proceed immediately to Rivington Street between Essex and Delancey. Block off and surround both sides of the street, institute immediate house-to-house search . . . ". The film thus actually maps out sections of the city for the spectator, sections that were threatened with urban renewal and blocks that would never survive the bulldozer's rout.

2 Twice-told stories about Times Square. As we have seen, the first-told story relied on a taste for realistic representation that grew out of a failure of memory effected by the disappearing city. But now we must draw a distinction between these earlier, realistic representations of urban space and our contemporary taste for simulation, for delight in wax museums, theme parks, retro-architectural splendors, and the suspension of disbelief that "planning can create the appearance of the unplanned". We are no longer searching for photographic realism, for mapping techniques, for documentary rendering of a city that is disappearing from our lived experience and collective memory. Now the narration of stories resides in the combinatorial codes of a computer memory, in the technical apparatus of simulation, in the regulatory controls of urban design. Thus Times Square is now only known through its representations, its sign systems, its iconic cinematic presence. It has produced an ontological confusion in which the original story has been forgotten and no longer needs to be told.

So we have allowed a quintessential public space of an American city to be redesigned as a simulated theme park for commercial entertainment. Architect Robert A. M. Stern's interim refurbishment plan extrapolates from the realism of the area's popular and commercial features and returns this to privileged spectators who can relish the illusion in a sanitized and theatricalized zone. This play with popular forms drawn from America's image-saturated commercial landscape, helps to destabilize the position that architecture once held in the city, for it no longer determines a city's unique visual identity but is reduced to nostalgia stereotypes. Drawing from a ubiquitous series of ordinary advertisements, signs and billboards, and even relying on the potential drawing card of Mickey Mouse and Donald Duck, Times Square has been incorporated into a larger sense of assembled space, where all of its simultaneity and immediacy can evaporate into astonishing imagescapes.

Today we bring all of our information processing abilities into play in order to demonstrate our technical and organizational power, and our planning regulations and design controls that can turn the material form of the city into such an effective illusion. Like any successful magic show, we are doubly thrilled when the illusion is produced by invisible means, when the prosaic world can be re-enchanted and disbelief suspended, albeit for a moment.

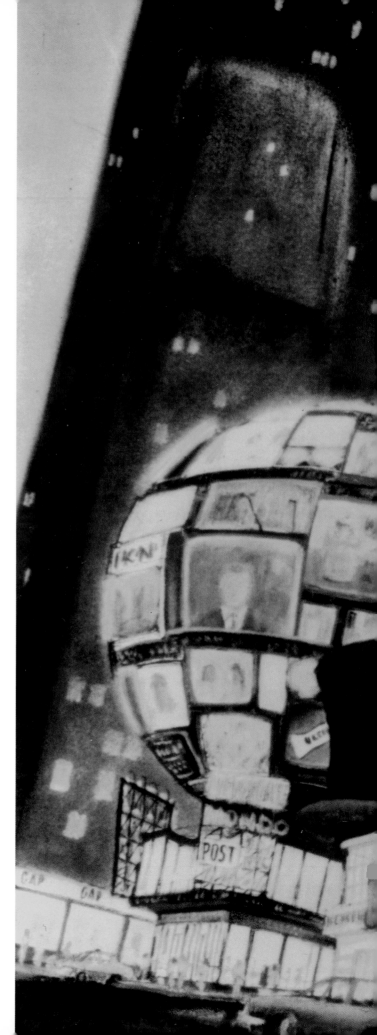

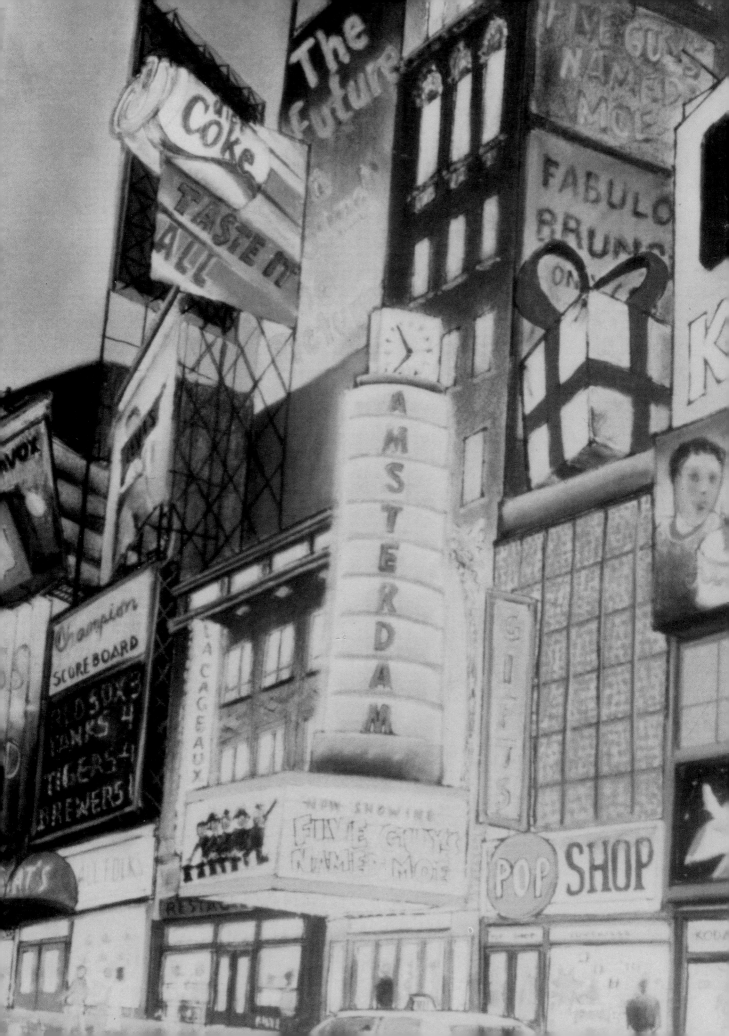

BENEATH THE PAVEMENT, THE BEACH: SKATEBOARDING, ARCHITECTURE AND THE URBAN REALM

IAIN BORDEN

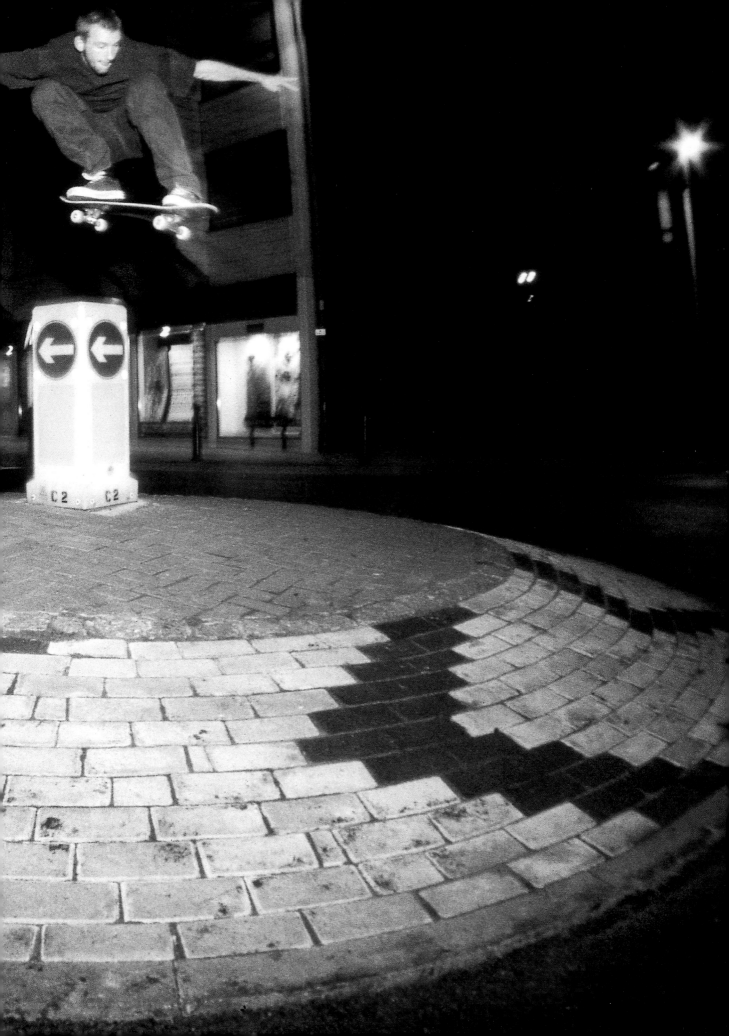

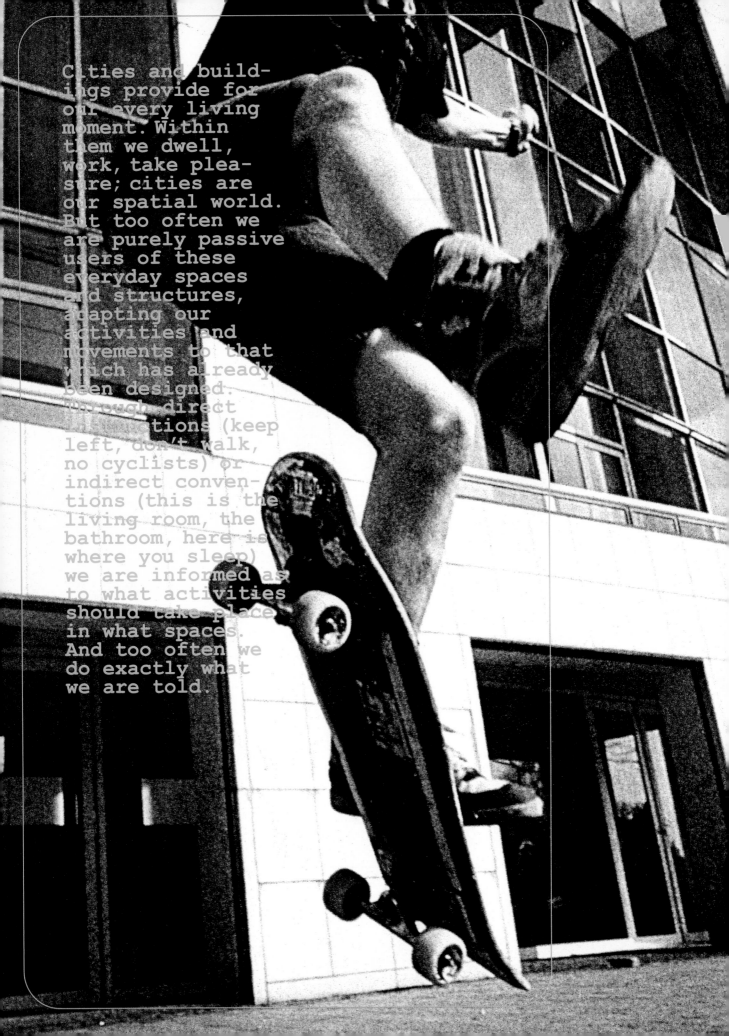

Cities and build-
ings provide for
our every living
moment. Within
them we dwell,
work, take plea-
sure; cities are
our spatial world.
But too often we
are purely passive
users of these
everyday spaces
and structures,
adapting our
activities and
movements to that
which has already
been designed.
Through direct
instructions (keep
left, don't walk,
no cyclists) or
indirect conven-
tions (this is the
living room, the
bathroom, here is
where you sleep)
we are informed as
to what activities
should take place
in what spaces.
And too often we
do exactly what
we are told.

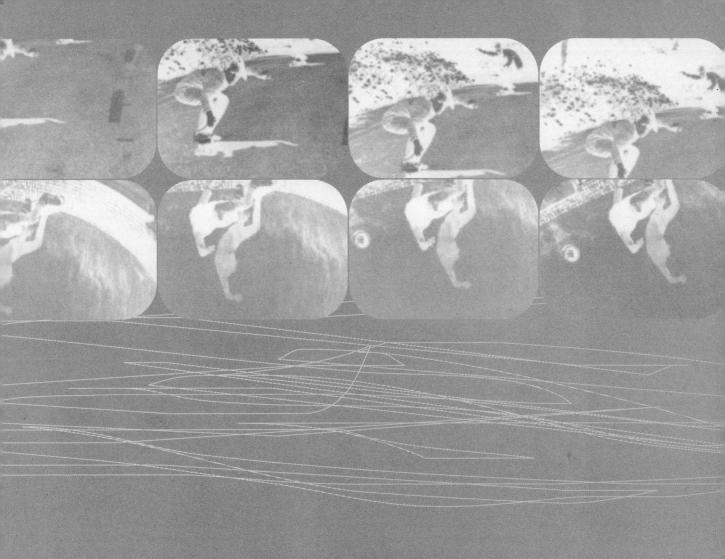

ut the city and its architecture offer us far more: the potential to do much more with our bodies than walking and driving, and to enjoy urban spaces ther than by working and shopping. By using forms of pleasure like play, the estival and the carnival (notwithstanding their own relation to commercialism nd capitalist "leisure time"), we can actively produce our own city experiences.

has often been remarked that decades of urban technology have unwit- ngly created a concrete playground of immense potential, and that it some- mes takes the mind of a 12-year-old to realise this potential. This comment efers to the urban practice of skateboarding.

he skateboard passed into mass public consciousness in the summer of 977; visible on every sidewalk, office plaza, parking lot and suburban road, he skateboard became an unavoidable part of urban life. After a subse- uent decline in popularity, skateboarding underwent a renaissance in the id 1980s and its practitioners are now more committed and more numer- us; there are skateboarders in every city right across the globe, creating sub-culture that offers a complete alternative to conventional city life, eplete with its own music, clothes and language. Skaters have a sense of elf and collective identity, and a way of engaging with the urban realm nique within the modern city.

kateboarding first arose in the 1960s on the sweeping roads of calm uburban sub-divisions. Surfers killed time by replicating ocean moves on mooth tarmac. But in the 1970s skaters quickly developed an urban char- cter, first appropriating deserted swimming pools, drainage channels and choolyard banks, and then reaching new physical and technical heights in urpose-designed skateparks in cities across America and Europe. Skaters ave used these specialist facilities to evolve a set of supremely body-

centric spaces, creating spiralling forces of movement that act centrifugally, extending out from the body to the terrain beneath, and then centripetally, pulling body, board and terrain together into one dynamic flow.

But since the 1980s, skateboarding has taken on a more aggressive, more political identity and space. After the closure of many of the skateparks, skaters were forced into the streets and here they create, on a daily basis, a radical subversion of the intended use of the city and its buildings.

Around 1984, skaters began radically extending skateboarding onto the most quotidian and conventional elements of the urban landscape. Using as their basic move the "ollie", in which the skater unweights the front of the skateboard to make it pop up into the air, they ride up onto walls of buildings, steps and street furniture. Skaters across the world now skate not just on the sidewalk but over fire hydrants, onto bus benches and planters, across kerbs and down handrails. As Stacey Peralta, a former professional skateboarder, describes it, "[f]or urban skaters the city is the hardware on their trip".

Skateboarders are antagonistic towards the urban environment. But beyond simple accusations that skaters cause physical damage to persons and to property, there is a more significant dimension to this seeming aggression; in redefining space for themselves, skateboarders threaten accepted defini- tions of space, taking over space conceptually as well as physically and so striking at the very heart of what everyone else understands by the city. Skaters produce an overtly political space, a pleasure ground carved out of the city as a kind of continuous reaffirmation of the notion that beneath the pavement, lies the beach.

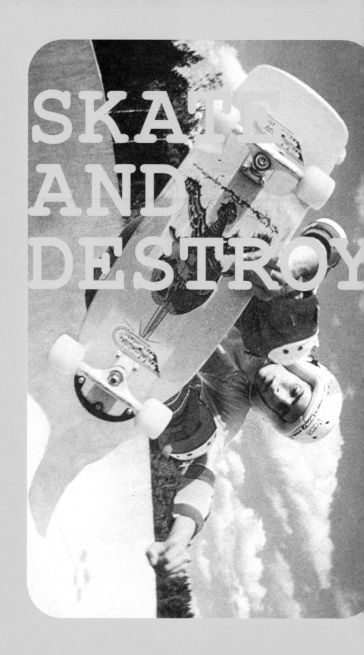

SKATE
AND
DESTROY

Nor is this by any means confined to America. Beside famous skateboarding cities like Los Angeles, Philadelphia and San Francisco, just about every developed capitalist city now has its own band of skaters. Skaters also increasingly communicate globally on the Internet, offering interviews, product reviews, video clips, still images, skateable locations and music.

Unsurprisingly, this kind of activity does not go unchallenged. Because skaters test the boundaries of the urban environment, using its elements in ways neither practised nor understood by others, they meet with repression and legislation. Some cities have placed curfews and outright bans on skateboarding. More usually, skaters encounter experiences similar to those of the homeless, for, like them, skateboarders occupy the space in front of mini-mall stores and office plazas without engaging in the economic activity of the building. As a result, owners and building managers have either treated skaters as trespassers or have cited the marks caused by skateboards as proof of criminal damage. Skaters face fines, bans, and even imprisonment – they are subjected to spatial censorship.

Anti-skateboarding legislation is rarely systematic, and skaters are often too young to pose a real threat, being without the various powers of self-determination held by adults. But the nervousness of the status quo highlights a confrontation between counter-culture and conventional, dominant social practices. Ultimately, being banned from the public domain becomes simply one more obstacle for skaters to overcome, causing them to campaign that "Skateboarding Is Not A Crime". Alternatively, such repression simply adds to the anarchist tendency within skateboarding, reinforcing the cry of "Skate and Destroy". Either way, skateboarders are part of a long process in the history of cities: a fight by the unempowered and disenfranchised for a distinctive social space of their own.

In doing so, skaters do not accept cities as they are; rather than trying to section off their own little piece of land, skaters want to use all of the city, and in a particularly unconventional and active manner. By using their youth and, in particular, by using their own bodily pleasure, skateboarders create their own space, their own cities, their own architecture.

THE CAFÉ:
THE ULTIMATE BOHEMIAN SPACE
ELIZABETH WILSON

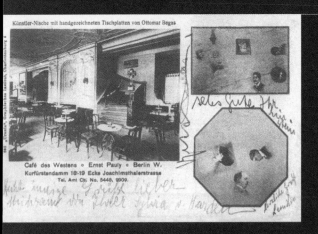

Café culture was the consummation of the bohemians' love affair with urban life. The salon, the restaurant, the club, the art gallery, the cabaret and the bookshop all played a role, but the café was crucial.

Bohemian life and café life are usually thought of as primarily Parisian, but cafés were citadels of bohemian existence all over Europe and America – even all over the world. One of the great bohemian cafés before the First World War was the Café des Westens (the West End Café) in Berlin. Nicknamed the Café Megalomania, it was the headquarters of the intelligentsia, the radicals, the Expressionists – all those struggling individuals caught between bourgeois society and artistic or literary ambition.

The café was the ideal bohemian venue because it was a chameleon environment, continually changing its purpose and atmosphere. It was first and foremost "a home for the homeless" – for nineteenth century and early twentieth century students and artists who lived in unheated lodgings, but who could spend whole days in the warm, dry café for the price of one cup of coffee.

At the turn of the century, the poet and "muse of Berlin", Else Lasker-Schüler, escaped the cold and poverty of her furnished rooms to live out her domestic and emotional life in the Café des Westens. Married to Herwath Walden, editor of the Expressionist magazine Der

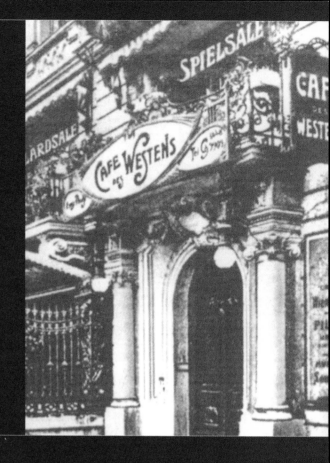

Sturm, she had a son from a previous (brief) relationship. According to the actress Tilla Durieux: "the couple, with their incredibly badly brought up son, could . . . be seen from midday until late at night in the café . . . with all the wild, arty young men and women. The little family nourished itself exclusively on coffee so far as I could see, brought by the hump-backed head waiter . . . who pityingly allowed them to defer payment, or for which an honest guest paid. The child, meanwhile, thoroughly at home, bore down on the plates of food and in the twinkling of an eye (while no-one was looking) took whatever he fancied." When in 1911 Herwath Walden fell in love with the Swedish journalist Nell Roslund, Else Lasker-Schüler was so upset that she tried physically to attack her rival, and Walden and the Sturm group had to move to another Café.

The café was also a labour exchange for intellectuals and artists, and the essential meeting place for journalists and editors, for artists, models and dealers before the invention of the telephone and the fax. Seated in a café you might meet the person who would change your life. That at least was the great hope – and of course the café was also a meeting place for lovers, an erotic as well as a business setting.

Cafés were also used as studies or libraries for individual work. A German intellectual described how every day by late morning the Café des Westens would be full of solitary artists sketching and writers scribbling. Only in the evening did conversation dominate. German writers particularly emphasised the seriousness of the café. There was a "rather formal atmosphere" in the Café des Westens, one of them recalled, (not the impression gained from some other descriptions). There was serious debate, not just unrestrained argument and posturing, "opinions or achievements were carefully weighed, sharply criticised". The people who met there were, this writer maintained, "the opposition", the anti-philistine. One young woman habituée of the Café des Westens, Clare Jung, recalled that its larger room "was not particularly attractive, but it did have something of an atmosphere of intellectual tension . . . Forced discussions . . . will never by conscious effort create an atmosphere like this. It must be something that has grown, developed out of the real conflicts of the age . . . [and in] the old Café Megalomania . . . at any hour of the day or night one could meet the people one wanted to talk with or start a paper with, open a studio with, form a group with."

Each café or even each table had its special clique: "Acceptance into any one of the literary circles was equivalent to swearing, an oath of allegiance to the prevailing artistic views of that circle", wrote the satirist Walter Mehring. "It was a vow not to publish a line anywhere but in the circle's publication, to obey the rules of order governing the circle's aesthetics and the circle's women [sic], and to fight the circle's polemics to the last drop of ink. And it was easier for a man to change his opinions than to change his café. For three centuries the feuds of Bohemia had been going on – table against table, café against café."

In addition, the café was a university. "The Café des Westens", wrote one of its habitués, was "a school, and a very good one at that. We learned to see here, to perceive and to think. We learned, almost in a more penetrating way than at the University that we were not the only fish in the sea, and that one should not look at only one side of a thing but at least at four." Cafés provided free newspapers and journals (as well as writing or sketching paper), and every guest could "sit for hours on end, discuss, write, play cards, receive his mail, and, above all, go through an unlimited number of newspapers and magazines". Presented with the entire journalism of Europe, including the rarest and most specialised journals, the clientele "knew everything that took place in the world first hand". In the 1990s the educational purpose of cafés is maintained at the Cyberia Café in North Soho, London, where customers can book time on the Internet, and take lessons in how to use it.

Yet the compulsive attraction of café life was not ultimately due to any of its practical uses, important as these were. Café life was an addiction, as Else Lasker-Schüler was well aware, and precisely because it was an addiction it involved a certain ambivalence: "I'm sated with the Café", she wrote, "but I will never on that account bid it farewell forever . . . On the contrary I shall return there. Yesterday the door opened, the door shut like a [busy] shop. Not everything, is genuine goods – imitation poets, false wordsmiths . . . unmotivated cigarette smoke . . . A corpse will one evening be found in the upstairs room . . ."

Even this ambivalence only made the café more compelling and addictive. The magical atmosphere arose because the café was a whole way of life. The café blurred the distinction between being "at home" or "out and about", between public and private, and it smudged the bourgeois boundaries between work and leisure. Everyone found there – or hoped to find – whatever it was that had made him or her set out on the journey to bohemia in the first place. The café, a shimmering bubble suspended in the urban atmosphere, was an actually-existing castle in the air; less a utopia, with all that "utopia" suggests of regulation and uniformity, than a "heterotopia", that is to say a place in which multiple divergent and contradictory experiences were to be had.

The café was theatrical, it was larger than life. At least it became so in the collective bohemian memory. It was the conversion of daily life into a total work of art.

ANDREOLI
bell hooks, *Yearning: Race, Gender, and Cultural Politics,* (Boston: South End Press, 1991).
Lucio Kovarik (ed.), *Social Struggles and the City: the Case of São Paulo,* (New York: Monthly Review, 1994).

BORDEN
Glen E. Friedman, *Fuck You Heroes: Glen E. Friedman Photographs 1976-1991,* (New York: Burning Flags Press, 1994).
Henri Lefebvre, *Critique of Everyday Life: Volume 1 Introduction,* (London: Verso, 1991).

BOYER
Christine Boyer, *The City of Collective Memory,* (Cambridge, Mass.: MIT Press, 1995).
Edward Dimendberg, "The Will to Motorization: Cinema, Highways and Modernity, *October,* n.73 (1995).
Edward Dimendberg, "Film Noir and the Spaces of Modernity", (Unpublished PhD Thesis).

CHAMBERS
Christine Buci-Glucksmann, *Baroque Reason: the Aesthetics of Modernity,* (London: Sage, 1994).
Iain Chambers, "Cities Without Maps", in *Migrancy, Culture, Identity,* (London: Routledge, 1994).
Susan Sontag, *The Volcano Lover: a Romance,* (London: Jonathan Cape, 1992).

CHARLEY
Guy Debord, *Society of the Spectacle,* (London: Practical Publications, 1977).
Karl Marx, *Capital: a Critique of Political Economy Volume 1,* (Harmondsworth, Middlesex: Penguin Books, 1976).

CURTIS
Michel de Certeau, *The Practice of Everyday Life,* (Berkeley and Los Angeles: University of California Press, 1984).
Rosalind Williams, *Notes on the Underground,* (Cambridge, Mass.: MIT Press, 1990).

HAYDEN
Dolores Hayden, *The Power of Place: Urban Landscapes in Public History,* (Cambridge, Mass.: MIT Press, 1995).
Lucy R. Lippard, *Mixed Blessings: New Art in a Multicultural America,* (New York: Pantheon Books, 1990).

KERR
John Allan, *Berthold Lubetkin: Architecture and the Tradition of Progress,* (London: RIBA Publications, 1992).
Joanna Mack and Steve Humphries, *The Making of Modern London, 1939-1945: London at War,* (London: Sidgwick and Jackson, 1985).

McCREERY
Stephen Kern, *The Culture of Time and Space 1880-1918,* (Cambridge, Mass.: Harvard University Press, 1983).
Patrick Wright, *A Journey Through Ruins: a Keyhole Portrait of British Postwar Life and Culture,* (London: Flamingo, 1993).

MASSEY
Derick Deakin (ed.), *Wythenshawe: the Story of a Garden City,* (Chichester: Phillimore, 1989).
Jean Greatorex and Sheila Clarke, *Looking Back at Wythenshawe,* (Timperley: Willow Press, 1984).
Doreen Massey, "A Place Called Home?", in *Space, Place and Gender,* (Oxford: Polity Press, 1994).

MENKING
Hakim Bey, *T.A.Z. The Temporary Autonomous Zone, Ontological Anarchy, Poetic Terrorism,* (Autonomedia Press, 1985).
Henri Lefebvre, *The Production of Space,* (Oxford: Basil Blackwell, 1991).

PIVARO
Marshall Berman, *All That is Solid Melts Into Air: the Experience of Modernity,* (London: Verso, 1982).
Rem Koolhaas, *Delirious New York: a Retrospective Manifesto for Manhattan,* (New York: Monacelli Press, 1994).

RENDELL
Walter Benjamin, *Charles Baudelaire: a Lyric Poet in the Era of High Capitalism,* (London: Verso, 1985).
Elizabeth Wilson, *The Sphinx in the City: Urban Life, the Control of Disorder, and Women,* (London: Virago, 1991).

SOJA
Simon Schama, *The Embarrassment of Riches: an Interpretation of Dutch Culture in the Golden Age,* (London: Collins, 1987).
Edward W. Soja, *Thirdspace: Journeys to Los Angeles and Other Real-and-Imagined Places,* (Oxford: Basil Blackwell, 1996).

WALKER
Jo Manton, *Elizabeth Garrett Anderson,* (London: Methuen, 1965).
Clarissa Campbell Orr (ed.), *Women in the Victorian Art World,* (Manchester: Manchester University Press, 1995).

WILSON
Walter Benjamin, *One Way Street and Other Writings,* (London: Verso, 1979).
Elizabeth Wilson, *Enchanting Bohemia,* (London: Hamish Hamilton, 1996).

GENERAL
Jon Bird et al (eds.), *Mapping the Futures: Local Cultures, Global Change,* (London: Routledge, 1993).
Iain Borden and David Dunster (eds.), *Architecture and the Sites of History: Interpretation of Buildings and Cities,* (Oxford: Butterworth, 1995).
Beatriz Colomina (ed.), *Sexuality and Space,* (New York: Princeton Architectural Press, 1992).
Paul Gilroy, *There Ain't No Black in the Union Jack: the Cultural Politics of Race and Nation,* (London: Routledge, 1987).
David Harvey, *The Condition of Postmodernity: an Enquiry into the Origins of Cultural Change,* (Oxford: Basil Blackwell, 1989).
Mike Keith and Steve Pile, *Place and the Politics of Identity,* (London: Routledge, 1993).
Edward Soja, *Postmodern Geographies: the Reassertion of Space in Critical Social Theory,* (London: Verso, 1989).
Michael Sorkin (ed.), *Variations on a Theme Park,* (New York: Noonday Press, 1992).
Sophie Watson and Katherine Gibson (eds.), *Postmodern Cities and Spaces,* (Oxford: Basil Blackwell, 1995).

MANIFESTATIONS

The Strangely Familiar programme currently consists of five projects: this document, the multimedia exhibition "Strangely Familiar" at the RIBA Architecture Centre in London and other venues, the symposium at the RIBA Architecture Centre on 27 January 1995, the Strangely Familiar Internet site, and an academic text, *The Unknown City*, (Routledge 1997). This *Strangely Familiar* publication is the first of these manifestations. Its form and content, collaboratively developed by Strangely Familiar and Studio Myerscough, aim to communicate both the intentions of the group and the ideas of the contributors. The emphasis on visual images and typographic devices enables complex issues about cities and architecture to be presented in a form challenging yet understandable to academics, professionals and members of the public alike.

The exhibition expands upon the imagery developed here. It utilises an inventive format, which mixes video, three-dimensional objects, music, spoken words and images to replicate the vibrancy of city life. The stories are also represented by an array of objects – shards of memory, time and space. The visitor can also access, via the multimedia component, the contributors personally narrating parts of their own tale of the city. By using communication technology in this innovatory fashion, the exhibition is visually stimulating, immediately accessible and richly informative, intended to be of interest to architects and design students but also to other urban professionals and the general public.

The design and construction of the exhibition is a collaboration, using the combined expertise of the Strangely Familiar team, the design practice Studio Myerscough and Allford Hall Monaghan Morris Architects, together with a group from the Arts Technology College (ARTEC) who have created the multimedia component. We have also relied on the expertise, efforts, support and goodwill of many other institutions and individuals, whom we acknowledge elsewhere in this document.

In addition to further British venues, a travelling version of the exhibition in Europe and USA presents the historical ideas to a far wider audience, while the Strangely Familiar web site on the Internet allows global participation.

An international symposium provides a forum for academics, practitioners, students and the public to discuss their ideas on cities and architecture. To encourage participation, contributors provide short presentations within themed areas, which form the starting point for a general, open discussion.

The academic text *The Unknown City: Contesting Architecture and Social Space*, edited by Iain Borden, Joe Kerr, Alicia Pivaro and Jane Rendell, takes the Strangely Familiar programme further into theoretical debates in architectural history, cultural studies and urban studies. This book is published by Routledge.

Strangely Familiar is an on-going project that will develop new initiatives in response to debates, ideas and criticisms generated by the work to date. Or, in the words of Karen Carpenter, "we've only just begun".

left to right
Iain Borden
Belinda Moore
Naomi House
Fraser
Joe Kerr
Lily Kerr Scott
Morag Myerscough
Alicia Pivaro
Jane Rendell

THANKS TO

John Allan
Christopher Ash
Ceri Barnes
Larry Barth
Chris Bird
Steven Connor
Nicole Crockett
Nick Delo
James Donald
Tom Duncan
Miles English
Paul Finch
Adrian Forty
Nick Franchini
Fraser
Sarah Gaventa
Kate Gaylor
Phil Grey
Naomi House
Steve Johnson
Lyndon Jones
Lily Kerr Scott
Richard Learoyd
Mark Logue and IE
Lee Mallett
Helen Mallinson
Jack Massey
Paul Monaghan
Sam Montagu
Nadine Nackasha
Lynda Nead
Gerard Nolan
Tristan Palmer
Mark Pivaro
Ellen Praag
Alan Read
Beth Rendell
Sidewalk Surfer
James Soane
Victoria Thornton
Kate Trant
Helen Tsoi
Marjorie Turton
Audio-visual at UCL
Raymond Winkler
World Backgrounds

SPONSORS AND SUPPORTERS

Arts Council of England
The Bartlett, University College London
ICA
Middlesex University
RIBA Architecture Centre
Sidewalk Surfer
University College London Graduate School
University of North London,
School of Architecture and Interior Design
Video-Log

Repro by Colourpath Ltd
0171 376 5523

Printed by Anderson Fraser
0171 833 7700

PHOTOGRAPHIC CREDITS

Group photo
Phil Grey

Cover photo
Belinda Moore

Akademie der Künste der DDR, Berlin
Anthony Borden
Iain Borden
British Architectural Library, RIBA, London
Iain Chambers
Jonathan Charley
Daniel Faust
The Fawcett Library
Greater London Record Office
Phil Grey
Andy Horsley/Sidewalk Surfer
Joe Kerr
Nelson Kon
Sasha Lubetkin
Marx Memorial Library
Doreen Massey
Nancy Massey
Belinda Moore
Morag Myerscough
National Monuments Record
Alicia Pivaro
Jane Rendell
Jim Simmons/Annette del Zoppo
Edward Soja
Robert A.M. Stern
UCLA Special Collections
John Webb, in Jean Greatorex
and Sheila Clarke, *Looking Back at Wythenshawe*, (1984)

In some cases we have been unable to trace the origins of images. We wish to thank in advance anyone whom we have inadvertently omitted.

First Published 1996
by Routledge
11 New Fetter Lane, London EC4P 4EE

Simultaneously published in the USA and Canada by Routledge
29 West 35th Street, New York, NY 10001

© 1996 edited by Iain Borden, Joe Kerr, Alicia Pivaro, Jane Rendell and designed by Studio Myerscough
Copyright of individual essays remains with contributors
Printed and bound in Great Britain by Anderson Fraser

British Library Cataloguing in Publication Data
A catalogue record for this book is available from the British Library
Library of Congress Cataloguing in Publication Data
A catalogue record for this book has been requested

ISBN 0-415-14418-3

SF 96